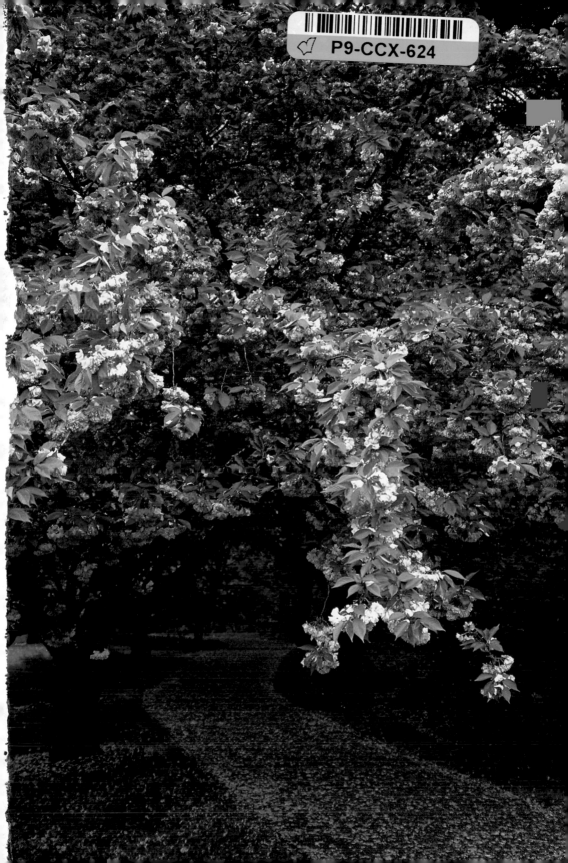

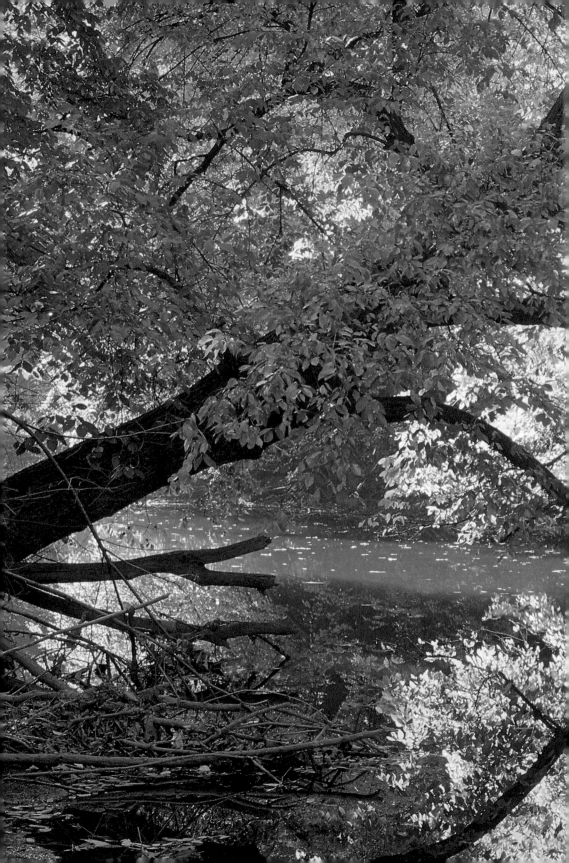

THE FIELD GUIDE TO PHOTOGRAPHING

TREES

CENTER FOR NATURE
PHOTOGRAPHY SERIES

ALLEN ROKACH
AND
ANNE MILLMAN

AMPHOTO BOOKS
AN IMPRINT OF WATSON-GUPTILL
PUBLICATIONS/NEW YORK

To our parents, who are our roots,

and to our children, whose

branches reach ever forward

PICTURE INFORMATION:
Page 1. Cherry tree. Westchester County, New York.
Pages 2-3. Fall reflection. The New York Botanical Garden.
Page 5. Maple tree. Westchester County, New York.
Page 6. Forest scene. Muir Woods, California.

Senior Editor: Robin Simmen
Editor: Liz Harvey
Designer: Bob Fillie, Graphiti Graphics
Graphic-production Manager: Hector Campbell

Text by Allen Rokach and Anne Millman
Photographs by Allen Rokach

Copyright © 1995 by Allen Rokach and Anne Millman
First published 1995 in New York by Amphoto Books,
an imprint of Watson-Guptill Publications,
a division of BPI Communications,
1515 Broadway, New York, NY 10036

Library of Congress Cataloging in Publication Data
Rokach, Allen.
 The field guide to photographing trees/by Allen Rokach
and Anne Millman.
 p. cm. — (Center for Nature Photography series)
 Includes index.
 ISBN 0-8174-3872-6
 1. Photography of trees. I. Millman, Anne. II. Title.
III. Series: Rokach, Allen. Center for Nature Photography series.
TR726.T7R65 1995 95-12035
778.9'34—dc20 CIP

Manufactured in Singapore

1 2 3 4 5 6 7 8 9/03 02 01 00 99 98 97 96 95

ACKNOWLEDGMENTS:
A book such as this necessarily has a long
gestation period, and many people con-
tributed—directly and indirectly—to its
birth. So we thank those individuals, past
and present, who enabled us to create it.

 We are grateful to our colleagues at
Amphoto Books, especially Mary Suffudy,
who first suggested that we do this series
of books and guided us in launching it,
and Liz Harvey, our editor, who helped us
navigate the treacherous waters of book
production and got us safely to shore.

 Friends at Olympus America, includ-
ing John Lynch, Dave Willard, and
Marlene Hess, as well as former Olympus
staff member Bill Schoonmaker and
Pasquale Ferazzoli, for their support and
encouragement.

 Thanks to the many new friends in
the botanical community who smoothed
the way, so that the images were easier to
take, especially Carl Suk of the Bernheim
Arboretum in Kentucky, Judith A. Gause
of the Holden Arboretum in Ohio, and
James W. Sutherland of Cantigny Gardens
in Illinois. And long before but still
remembered, two members of The New
York Botanical Garden family who
showed great faith and confidence in an
inexperienced photographer and strength-
ened his acquaintance with trees and
flowers: James M. Hester, former presi-
dent, and Marge Lovero, former director
of public relations.

 Special thanks to those who supported
various travels that helped us gather
images: Odette Fodor, KLM director of
public relations; Kathy Barbour of Thai
Airways International; Nat Boonthanakit
and Suraphon Svetasveni of the Tourism
Authority of Thailand; Barbara Veldkamp
of the Netherlands Board of Tourism;
Barbara Cox of Royal Cruise Line; and
Priscilla Hoye of Cunard.

 We appreciate the encouragement
we've gotten over the years from Herbert
Keppler and Jason Schneider of *Popular
Photography*.

 And some final words of appreciation
to Frank Kecko, a caring and helpful com-
panion on our many picture-taking trips
together, and to Kay Wheeler and Sidney
Stern, whose tireless assistance in the
office and studio has moved many pro-
jects to completion.

Contents

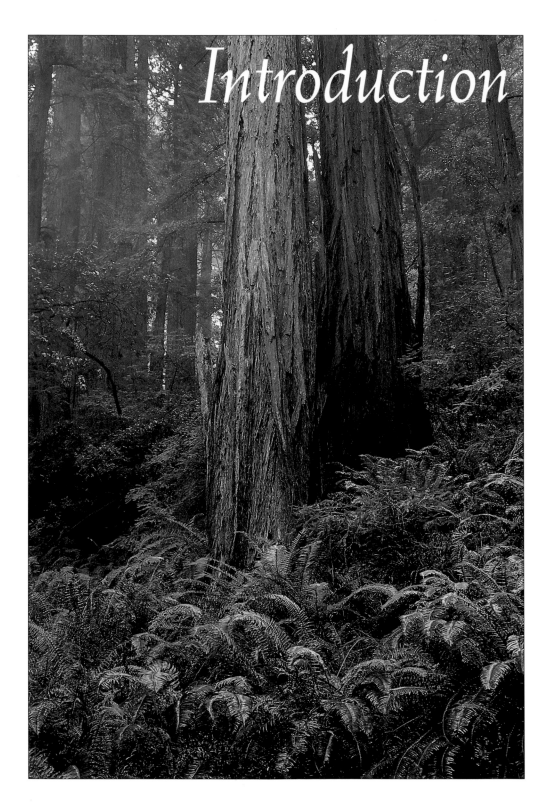

Introduction

The direct and vital link between trees and human beings is a connection that poets, mystics, and artists have expressed through the ages. People know subliminally, if not consciously, that their world—the air they breathe, the atmosphere that blankets the globe, and the soil that nourishes future growth—depends on the existence of trees.

In recent years, the rapid destruction of the rain forest and the increased encroachment of deserts have alerted people to the important role trees play in preserving the delicate balance of the ecosystem. Anyone who loves nature and is concerned about the environment wants to find ways to communicate how special trees are. We believe that one path to take is to photograph trees. Trees may not be cute and cuddly, but you can portray them in ways that allow viewers to develop an emotional attachment to them. The more other people begin to see and truly appreciate trees, the more, we hope, they'll care about the trees. Although trees appear strong and stalwart—and in some ways they are—they are also fragile and all too vulnerable.

Our own appreciation of trees grew gradually over the years. We learned the different characteristics of trees during years spent at The New York Botanical Garden and its sister institution, The Mary Flagler Cary Arboretum. As a photographer-and-writer team, we saw the painstaking, determined efforts of botanists to ferret out the secrets of their silent subjects. We watched as they probed and tested, often taking years to determine a small piece of useful information. We also saw how difficult it was to make the public care about the ravages of acid rain and other looming disasters when pitted against the competing claims of economic development.

Our fondness for trees grew as we explored America's national parks and other areas of natural beauty. Again, our senses awakened to the need to preserve for the future what our predecessors had such foresight to protect on our behalf. This was a legacy we had to pass on.

And finally, on a more purely aesthetic level, we came to value the role of trees in the garden. We saw how talented landscape designers, such as the late Russell Page, England's preeminent garden architect, worked with these massive forms, using them, in the words of Page, as "the bones of the garden." We saw trees as the fundamentals of a garden's plan, and as the foundations of the natural world.

So the question we asked ourselves was, "How can we contribute to a greater appreciation of trees?" And our answer was to simply encourage other people to look at them, particularly with their cameras in hand. We knew that photographers, out of necessity, must look at their subjects with great sensitivity. They come to notice features they wouldn't have seen in a quick, drive-by glimpse. When people slow down and become immersed in the process of exploring and discovering what trees have to offer visually, we believe that they'll also care more about what happens to trees, whether in their own neighborhoods or in the world.

In a very real sense, then, this book is about learning to love trees through photography. We hope the images convey the grandeur and majesty of trees, as well as their more tender qualities. Most of all, we hope the images capture the spirit of trees, their range of personalities, and the sweep of emotions they are capable of sparking. It is through their feelings that people develop a sense of true kinship with trees.

ANNE MILLMAN

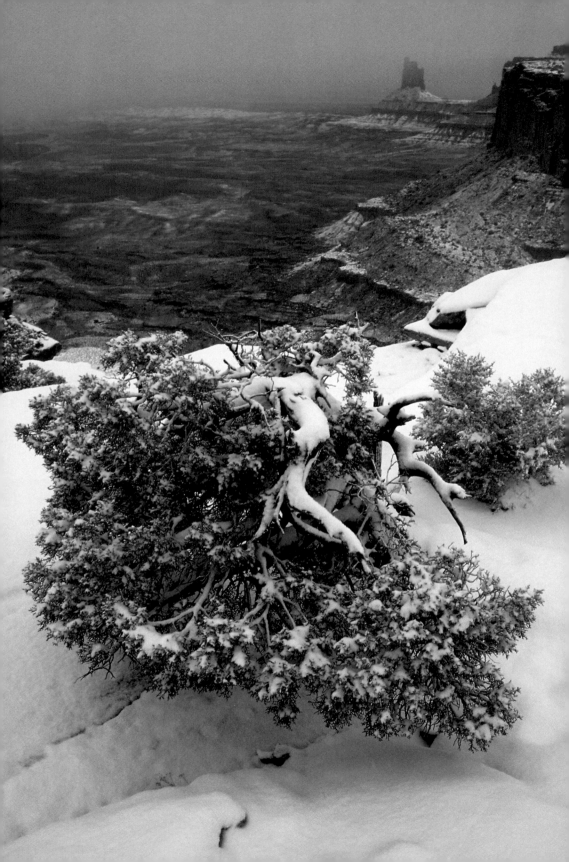

CHAPTER 1

Looking at Trees

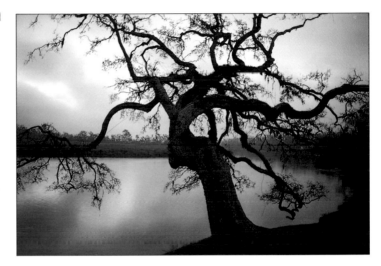

An ancient juniper tree, gnarled and wind-bent, makes an expressive subject in this monochromatic winter portrait, which I made at Canyonlands National Monument, Utah. While many people would ignore such an imperfect tree, I saw it as a symbol of life's tenacity in an inhospitable environment. In addition, the tree's shape and texture contrasted beautifully with the sweeping landscape behind it. With my Olympus OM-3 and Zuiko 35-70mm zoom lens, I exposed Fujichrome 100 RD Professional film at f/11 for 1/30 sec.

This tree's brooding shape gave an eerie feeling to this scene along the banks of a South Carolina river. To emphasize the sense of mystery, I shot the tree in silhouette, underexposing by one stop. I used a slow shutter speed of 4 seconds to unify the pale blue tones in the water and the sky. Working in the early-morning hours with my Olympus OM-4T and my Zuiko 28mm wide-angle lens, I exposed Kodachrome 64 for 2 seconds at f/11.

Trees are so much a part of our everyday lives that, like so many other things we see on a daily basis, we tend to take them for granted. This may explain why nature photographers don't pursue tree images with the same fascination and enthusiasm that they bring to other nature subjects, such as flowers, landscapes, and wildlife. How often have you heard of people taking a special trip just to look at particular trees?

Even if we don't appreciate trees as fully as we might, they certainly are visual delights. Just think of writer Joyce Kilmer's famous line, "I think that I shall never see a poem as lovely as a tree." And, in general, trees cooperate well with photographers and make themselves readily available, which can't be said of all nature-photography subjects. Trees are, in fact, a nature photographer's dream come true—if only their value were more widely recognized.

So, don't consider this volume to be just a how-to instruction manual. Consider it an advocacy tract. Let it help you to open your eyes, get you to look at trees more consciously, and inspire you to appreciate trees as the worthy photographic subjects they truly are.

As soon as I came upon this dense stand of bare aspen trees in Colorado, I knew that it defied simple depiction. Looking up, I saw a way to portray these slender trees as they reached toward the sky. With my Zuiko 21mm wide-angle lens on my Olympus OM-4T, I crafted a graphic image of the converging lines. I used a polarizer in order to both deepen the blue of the sky and bring out the highlights. The exposure on Fujichrome 100 RD Professional film was 1/30 sec. at f/16.

When I noticed this spring scene at The New York Botanical Garden, I envisioned an image that would show the color parallels between the crab apple tree and a nearby tulip bed. My idea was to create a series of visual bands, pale pink at the top and bottom and green in between, with a slight tilting to suggest the sloping hillside. To keep the tree the center of focus both technically and visually, I blurred the tulips slightly. For this shot, I used my Olympus OM-4T and Zuiko 35-70mm zoom lens, and exposed for 1/125 sec. at f/8 on Kodachrome 64.

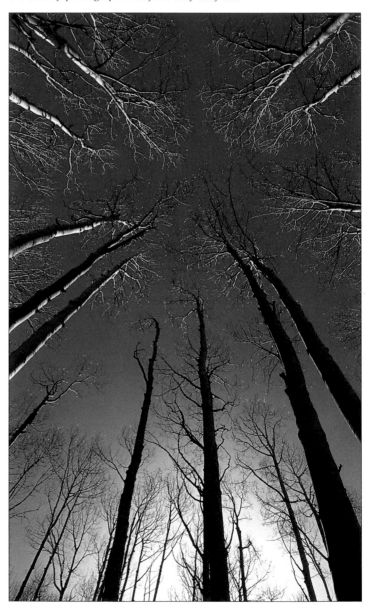

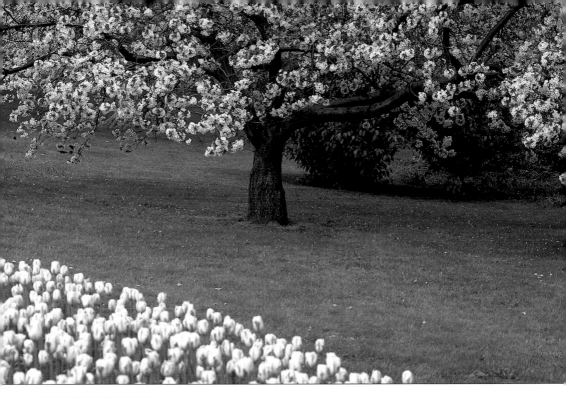

THINK VISUALLY

What do you like most about trees? The beauty of fall foliage? The texture of the bark? Perhaps the shape of an individual tree? The way a particular tree stands in its surroundings? Whatever qualities delight the eye and appeal to you are often the very same ones that make you want to take pictures of trees.

Your interest would grow immeasurably, however, if you could extend your vision by thinking visually and seeing photographically. Whatever your eyes can see, you can see much more through the camera's lens. How is this possible? It happens because photographic processes transform what is into what could be. Without that indispensable insight, your journey down the road toward thinking visually will be thwarted and unrealized.

While most competent photographers can simply record a subject, the truly imaginative ones extend our understanding by portraying aspects of the visible world that most people don't see. Talented photographers also reveal dimensions most people don't easily notice and create pictures that go beyond anything the ordinary eye can glimpse. Such images are the result of superior photographic vision.

This chapter maps out, and subsequent chapters spell out in detail, what it takes to think visually and develop a strong photographic vision. Photographic seeing starts by learning how to identify what is worth capturing on film—what is photogenic, not just beautiful. Even a tree that falls far short of perfection as a botanical specimen may spark your imaginative powers, thereby motivating you to record an expressive image on film.

How can you recognize these photogenic qualities? Initially, you rely on your emotional response to a potential subject. Chances are that your reaction is to something with photographic possibilities. Think about it a while. What catches your eye? Is it the impact of light on the subject? Is

(Overleaf) I first passed this row of trees overlooking a Dutch canal during the day. I decided to return toward sunset to see if I could make a special image incorporating their reflections. I waited until after sunset to take this shot, dramatizing the rich afterglow as the main attraction. To brighten the dark reflections, I metered them and then shot at 2/3 stop over that reading. With my Olympus OM-4T and Zuiko 35-70mm lens, I exposed for 1/4 sec. at f/11 on Fujichrome 100 RD Professional film.

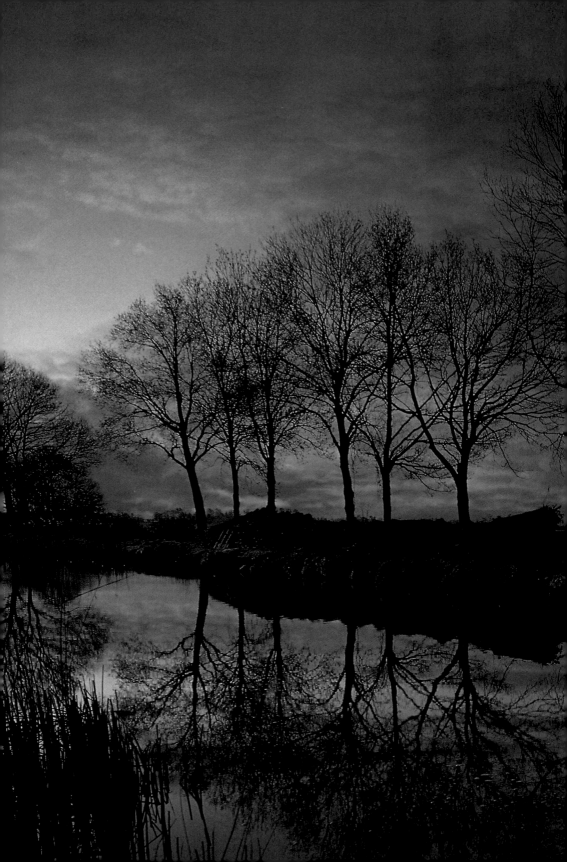

I wanted to contrast the delicate texture and color of this huge weeping willow tree with the budding magnolia tree. To compress the space between these two subjects, I decided to work with my Zuiko 180mm telephoto lens. Then I composed the scene tightly, cropping the willow, to concentrate the effect of the soft spring backlight. Shooting in suburban Westchester County, New York, I used my Olympus OM-4T and exposed at f/11 for 1/4 sec. on Kodachrome 64.

it something in the subject's shape, color, or texture? Is it the relationship between the tree and its setting? Then look again, more closely and critically, as you analyze your subject. How would the use of a telephoto lens or a wide-angle lens affect the image? What needs to be sharp? What can you render out of focus? What is the best exposure for the image?

As you gain experience and increase your technical know-how, you'll become more confident about seeing many possibilities in your mind's eye. You'll know that when you select a slow enough shutter speed, even the dimmest light can accumulate on film and look like daylight. And you'll understand how to enrich and lighten colors through under- and overexposure.

Finally, you'll be able to previsualize an image, letting your imagination shape the raw materials before you. This mental vision will guide you in deciding what equipment and techniques to use. You'll be the master of your tools, learning to control your camera, lenses, and films via techniques that help you record not only what you actually see, but also what you imagine. And you'll make decisions about shutter speeds, ƒ-stops, lenses, and other technical options with full knowledge of how these variables can best serve your creative purpose. Once you free your imagination by thinking visually and seeing photographically, you'll look at trees with new eyes.

KNOW YOUR PURPOSE

Masterful photographs of trees begin with your previsualizing a clear, mental image of the photograph you want. Although this sounds simple, it is often easier said than done. In order to help you clarify your goal, you should think about the purpose of your shot. Why do you want to take this particular photograph? What especially appeals to you about the subject? Finding the words to express these ideas will enable you to identify your purpose.

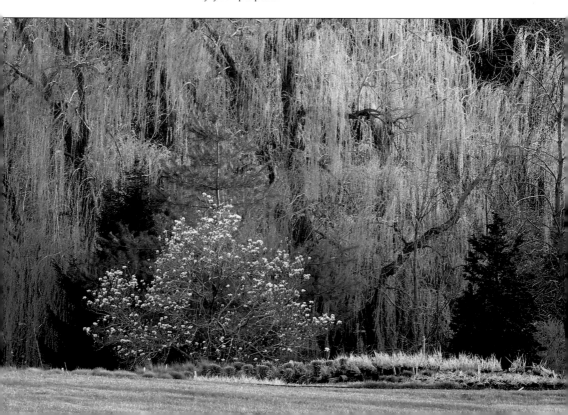

Many of our workshop students have found it helpful to complete the statement, "I want to." Use this strategy whenever you have trouble defining your photographic purpose. By focusing your attention on what is most important to you about a subject, this statement helps you make decisions about formal framing and technical options.

Complete the purpose statement as precisely as possible: "I want to evoke a romantic mood using the flowering trees along this path," "I want to capture the delicate light behind this dark tree trunk," or "I want to contrast the coarse texture of this tree with the smooth, round stones at its base."

Your purpose may be primarily documentary photography. For example, you may want either to portray a scene or panoramic vista that includes a well-shaped tree or to capture the rich colors of fall foliage along a trail. On the other hand, your purpose may be to create a more impressionistic image. You may want to underscore the delicate light that filters through a forest after a drizzle; dramatize the backlight on trees bending over a calm pond; or create a powerful abstract image using the shapes, textures, and colors of trees. Of course, no two people will have exactly the same purpose, even if they're shooting exactly the same subject. That is part of the joy of photography: you envision the possibilities in your own individual way.

Once your purpose is clear, you are ready to follow one of our ten commandments of nature photography: Less is more. Ruthlessly eliminate whatever isn't essential to your purpose in each frame, and include only what contributes to the final image. Then you can analyze the technical choices that will help you achieve your goal.

UNDERSTAND THE TECHNICAL OPTIONS

Of course, vision without technique will leave you frustrated since your results won't match your expectations. And technique without vision will leave your audience frustrated since they won't know why you bothered

This image represents an exercise in abstract composition. I found the brightly painted houses in this French Riviera town charming. A solitary tree growing in a small plaza sparked an idea to let the ochre wall and the turquoise windows provide a backdrop of contrasts in color and shape. I composed carefully in order to retain only part of the tree. I wanted to include just enough foliage to show the rim of the tile roof, and only enough of the trunk to include the top of a neat hedge at the lower part of the scene. In this way, the greens at the top are echoed at the bottom. Working with my Olympus IS-3 and its built-in Zuiko 35-180mm zoom lens, I exposed Ektachrome Lumière LPP film at f/8 for 1/15 sec.

Working on a bridge in
New Jersey's Branch Brook
Park, I found a downward
perspective that showed a
variety of blooming cherry
trees in spring. To isolate a
portion of the distant scene
and bring out the trees'
textures, I set my 180mm
telephoto lens at f/5.6.
Because the wind was
blowing, I decided to take
several shots at different
shutter speeds to see how
the movement would
record. I liked the slight
swaying effect in this shot,
which I made by setting a
slow shutter speed. With
my Olympus OM-4T and a
Zuiko 180mm lens, I
exposed Fujichrome Velvia
at f/5.6 for 1/2 sec.

to take the picture. If your photographs of trees are to be satisfying to
you and to your viewers, vision and technique must work hand in hand.
The challenge is to understand the technical variables well enough, so
that you choose them to help you create your hoped-for image.

Consider the following technical options as you begin to experiment
with photographing trees.

Lenses. Your eyes see the world from the same perspective at all times.
A camera that has interchangeable or zoom lenses lets you change
perspective easily. By using a telephoto lens, for example, you can bring
distant trees closer; isolate a single tree in a field; or compress the space
between trees that are near and far, thereby juxtaposing their shapes or
concentrating their colors.

With a wide-angle lens, on the other hand, you can broaden your
perspective, even at close range. The resulting effect, which some people
consider distorting, gives you a number of options. You can encompass
an entire tree within the frame, combine several trees in a tight composi-
tion, or stretch the space between foreground and background trees. If
you aren't familiar with the effects of various lenses, experiment with
someone else's equipment before you decide what to buy. And when you
are ready to shoot, choose the lens or lenses that will best enable you to
achieve your previsualized images.

Shutter speed. Another technical difference between the photographic
process and the way the human eye sees is that a camera's shutter speeds
can be changed. You can select the exact length of time you want the
shutter to remain open. The ability to set the shutter speed lets you
control two variables: motion and light intake. Shutter speeds of 1/8 sec.
or slower reveal motion, while shutter speeds of 1/125 sec. or faster
freeze movement. If the wind is blowing, take several shots at different

shutter speeds to see how the movement of swaying branches or tossing leaves records on film. Keep careful notes about your camera settings, so you can learn from your results. This way, in the future you'll know which shutter-speed setting to use for the effect you want.

As for light intake, the slower the shutter speed, the longer the light continues to enter the camera lens and strike the film. A film's capacity to accumulate light can permit you to shoot in virtual darkness, creating images no eye has seen, such as trees in a moonlit setting or silhouetted against the ball of the setting sun.

Aperture. A camera's f-stop settings vary the size of the aperture, which is the opening in the lens diaphragm that allows light to enter the camera. The size of the aperture lets you control two variables: depth of field and light intake. One of the chief differences between the way the human eye sees and the way the camera sees involves depth of field. The human eye can't focus on two distances at the same time, but the camera can. The size of the aperture permits you to control how much of an image will be in focus, from foreground to background.

You should set your aperture according to the extent of sharpness you want throughout a photograph. Small aperture settings, such as $f/16$ or $f/22$, provide the most extensive depth of field, or greatest sharpness range. (Not all cameras are equal in this regard. The newest "smart," automatic, point-and-shoot cameras are a decided improvement over earlier ones, but controlling their depth of field is more complicated than controlling that of manual cameras. See Chapter 2 for more information.)

In general, you'll want your tree images to be as sharp as possible; therefore, use the smallest aperture setting you can in order to maximize depth of field. But a particular image may call for partial sharpness, which

Here, my purpose was to photograph the setting sun through the branches of this solitary tree in a Dutch hayfield. After finding the best location, I chose a powerful 250mm lens setting. I wanted the tree to appear isolated in its setting and the disc of the sun to remain large behind the tree. To maintain color saturation, I metered the sky at its brightest point, excluding the sun. Then I shot at the meter reading, which deepened the colors of the sky and rendered the tree a silhouette. With my Olympus OM-4T and Zuiko 50-250mm lens, I exposed for 1/30 sec. at $f/11$ on Fujichrome 100 RD Professional film.

While working in Colorado, I decided to compress the space between these near and far trees. I knew that this approach would juxtapose the shapes of the aspens and concentrate their colors. With my Olympus OM-4T and my Zuiko 100mm telephoto lens, I exposed Fujichrome Velvia for 1/30 sec. at f/16.

you can achieve via more limited depth of field. So, for example, to portray a sharply defined tree in the foreground with an out-of-focus background, you should choose a large aperture setting, such as f/2.8 or f/4.

Keep in mind, though, that your choice of aperture setting will also affect exposure. For the exact light intake you need—the best exposure in each lighting situation—you'll have to choose the best combination of shutter-speed and aperture settings. The amount of light you let into the camera will affect color rendition, image brightness, and other photographic qualities. (See Chapter 3 for a full discussion of using natural light in tree photography).

Focus. Focusing isn't a major concern for most tree photography since you can take your time to be accurate. However, successful focusing requires you to know precisely where to focus. From a distance of 50 feet or more, you are likely to focus at infinity. If you are less than 50 feet from your subject or if you're shooting upward, the rule of thumb is to focus on a point roughly one third of the way up from the bottom of the frame.

With most 35mm single-lens-reflex (SLR) cameras, you can see through the viewfinder precisely what will be in focus in the final image. But all cameras have a mechanism, such as matching overlapping images, for bringing a particular point in the viewfinder into the sharpest focus. This can happen either manually or automatically.

The camera's focusing mechanism works by moving the glass elements within the lens forward or backward. With manual focusing, the photographer rotates the focusing ring on the lens until the image appears sharp or until the "split image" comes together. With automatic focusing, the camera emits an electronic beam aimed at the subject, which bounces back to the camera at lightning speed so the camera automatically focuses on that point. Manual focusing affords the photographer more control than automatic focusing does, but autofocus has advan-

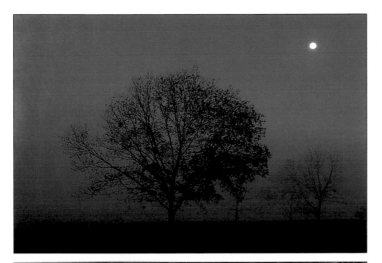

Film has the capacity to accumulate light and to affect color rendition. I was able to create this tree silhouette at Kentucky's Bernheim Arboretum in virtual darkness. Working by the light of the moon, I needed a very long 8-second exposure and used Fujichrome Velvia to turn the black sky blue. After taking a spot-meter reading of the sky, I took a series of shots, bracketing at 1/2-stop increments toward overexposure. With my Olympus OM-4T and Zuiko 35-70mm zoom lens, I shot at f/4, one full stop over the meter reading.

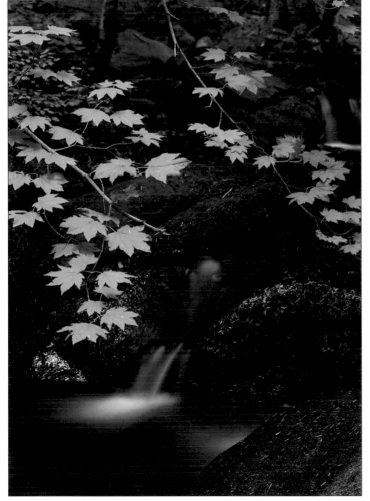

For this shot, taken at Mount Rainier National Park in Washington, I had to find a way to combine the nearby leaves, which were in bright overcast light, with the darker scene behind them. At the same time, I wanted to capture the flow of the woodland stream. Having to compose from a small bridge, which gave me little space for maneuvering, further complicated the technical issues. I solved my problems by experimenting with various lenses until I found the one that provided the desired perspective: a 35mm medium-wide-angle lens. I knew that I had to use a slow shutter speed of 1 second to blur the flowing water. In addition, this setting let me use the lens' smallest aperture to maximize depth of field while focusing on the leaves, as well as provided acceptable exposure in both the bright and dark portions of the scene. Shooting with my Olympus OM-4T and Zuiko 35mm wide-angle lens, I exposed Kodachrome 64 for 1 second at f/16.

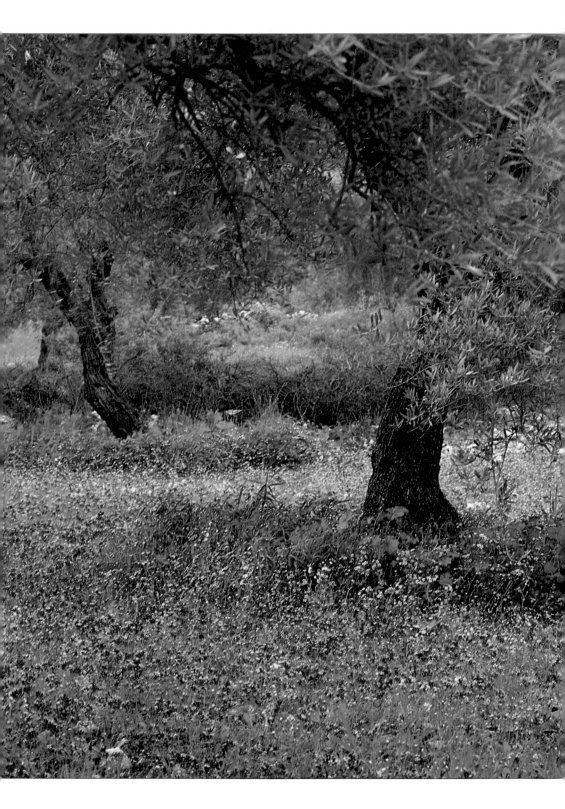

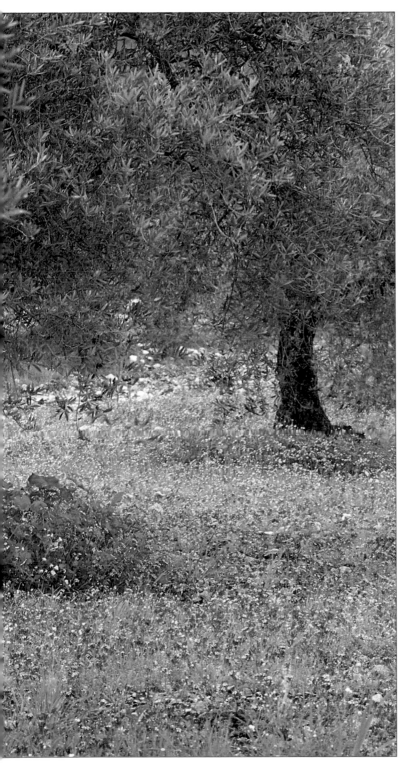

Working in Israel, I wanted to sharply define these gray and green olive trees while throwing the surrounding wildflowers out of focus. To achieve these effects, I had to limit depth of field. I accomplished that by using my Zuiko 100mm telephoto lens and a wide-open aperture of f/4. Then I focused on the leaves of the nearest tree. With my Olympus OM-4, I exposed at f/5.6 for 1/250 sec. on Fujichrome 100 RD Professional film.

Rules aren't as important as your personal vision. This silhouette, which I shot at the Bernheim Forest in Kentucky, defies the Rule of Thirds. While composing this image, I placed both the vertical main subjects and the horizon line slightly off center. I kept moving until I found a viewpoint that integrated all the important elements: the foreground trees, the mist, the background trees, the ground line, and the line of the ridge in the distance. I wasn't satisfied until I discovered this slightly asymmetrical arrangement. Working with my Olympus OM-4T and Zuiko 35-70mm zoom lens, I exposed Fujichrome 100 RD Professional film for 1/4 sec. at f/11.

A dull sky requires camouflage. By carefully positioning the tawny fronds of a weeping willow tree on the grounds of the PepsiCo Corporate Headquarters in suburban Westchester County, New York, I minimized the weak sky in this shot. At the same time, I played up the strength of the tree, showing its delicate, hairlike twigs swaying in the breeze. I then placed the foreground tree to the side in order to reveal both the wintry landscape and the other trees in the background. Working with my Olympus OM-4 and Zuiko 28mm wide-angle lens, I exposed Kodachrome 25 for 1/15 sec. at f/11.

tages when the subject is moving. Since trees are stationary, you should stick with manual focusing to retain precision and control.

LOOK BEFORE YOU SHOOT

You've thought hard about the kind of image you want. You've identified the aesthetic elements that appealed to you as well as clarified what you want to feature in your picture. You've analyzed the technical options and made your choices. Nevertheless, you still have more to do before you depress the shutter-release button.

To actually create the image, take a few extra moments to make sure everything is in place. Paying determined, methodical, and careful attention to the minutest detail makes the difference between an ordinary tree photograph and an extraordinary one. Complete the following final steps before you press the shutter.

Select the most promising viewpoint. Don't assume that the first impression is the best. Study your subject carefully, and think about how changing your camera position could make the composition stronger or the image more interesting. Move around—toward your subject, around it, and away from it. Look at it from above or below. As you do, notice how

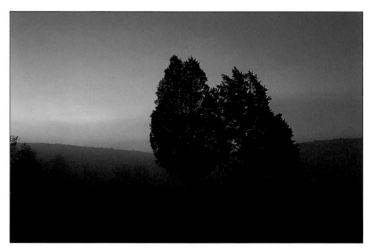

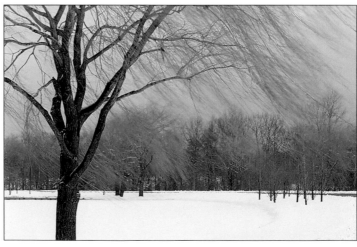

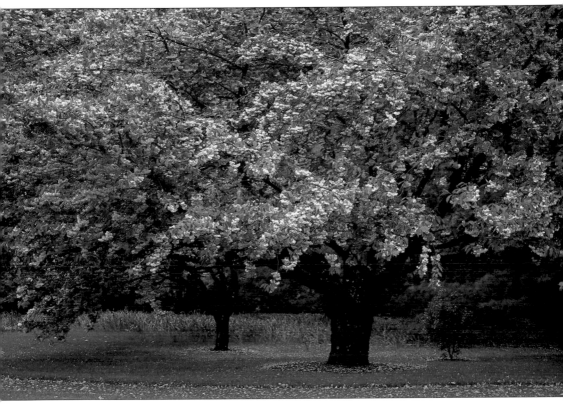

each small move changes the lines in the composition or the relationship of various shapes. Don't shoot until you have an optimal viewpoint.

Maximize strengths, and minimize weaknesses. Let the best parts of your subject dominate the composition. Arrange the flow of lines, shapes, colors, and/or textures in such a way that they play to the most compelling elements. Organize the patterns of light and shadow, especially in the background, to make them supporting actors to your star attraction. Notice any distracting aspects in the scene, and find ways to disguise or eliminate them. You can achieve this either by changing your shooting position, tipping your camera, switching your lens, or using a different format.

Edit in the camera. Photographers tend to fall in love with their subjects and see what they wish to see. But the camera sees everything. So, train your eye to be just as objective as your camera by examining the entire plane of the film frame, to the edges and into the corners. Then ruthlessly eliminate whatever is unnecessary by moving closer, changing perspective slightly, selecting a different lens, or throwing unwanted elements out of focus. Keep only what you want in your final image.

Take a lot of photographs. No matter how glorious your image seems through the viewfinder, you can't be absolutely sure how it will look until your film is developed. Therefore, you should bracket to increase the odds of getting at least one outstanding exposure. As extravagant as this may sound, it is well worth it since the opportunity to photograph under the same conditions is virtually impossible. But keep in mind how changing the ƒ-stop or shutter speed will affect depth of field and movement as well as exposure.

Color and texture are the main elements in this shot of cherry trees, which I came across in New York's Westchester County. To concentrate the color and focus attention on the blooms, I cropped in tightly, eliminating the tops of the trees. This approach created a broad band of pink at the top of the frame, which I balanced with a contrasting band of deep colors below. Next, I fine-tuned the image by incorporating the line of the path at the base, already strewn with fallen petals. I made this shot with my Olympus OM-3 and my Zuiko 100mm lens. The exposure was 1/15 sec. at ƒ/11 on Fujichrome 100 RD Professional film.

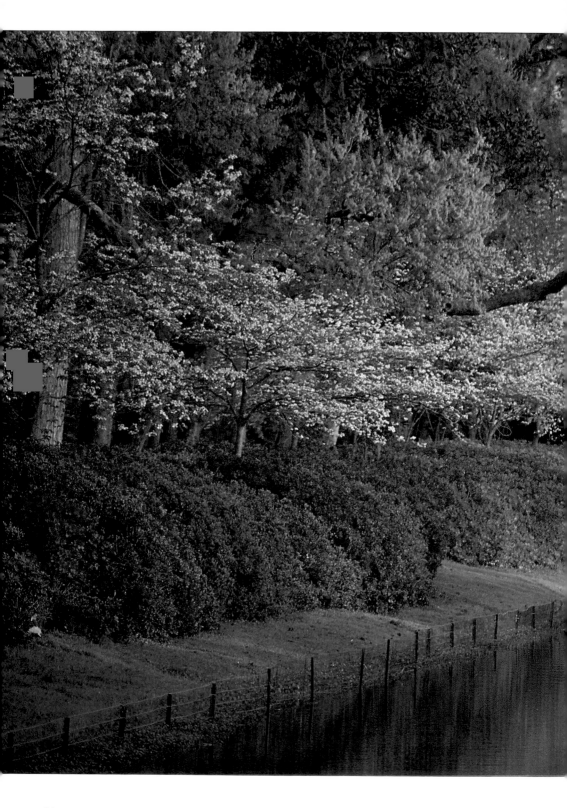

The spring bloom in the Middleton Garden near Charleston, South Carolina, offers a wealth of visual riches. In such circumstances, it is often hard for photographers to know which way to turn. Don't assume that your first impression will produce the best result. This was one of many shots I took as I circled the pond searching for new images. Although the trees play only a supporting role, they frame the rest of the elements so well that I consider this the strongest of the lot. This picture shows the care with which the landscape designer planned this exquisite garden. With my Olympus OM-4T and Zuiko 35-70mm zoom lens, I exposed at f/16 for 1/30 sec. on Fujichrome Velvia.

Never say done. The best photographers keep working to improve an image, coming up with subtle variations of an image until they absolutely must move on. The essence of creativity is this desire to keep pushing your own imaginative limits and never giving up until you've tried every possibility you can think of.

DISCOVER THE SEASONS

One of the most natural and fascinating ways to keep pushing your own imaginative limits is to look at trees in every season. This approach not only breaks the habit of viewing trees solely at their peak, but also lets you see aspects of nature—and trees in particular—with a sense of discovering something new and unfamiliar.

And just as each tree has a unique character, each season of the year reveals another dimension of that personality. These changes have great symbolic and visual potential, which poets have known through the ages. Despite our increased understanding of the workings of nature, the unfolding of the seasons is still both mysterious and magical. You have endless opportunities to reawaken your imagination as you explore it with your camera.

Spring. This is the time of rebirth and youth, and trees reflect the exuberance of the season by bursting into bloom and unfurling their pale green leaves. Try to capture the essence of spring in the new greens and other pastel colors you'll find in abundance. Look particularly for flowering trees, fallen petals, and trees combined with flowers. You should also take renewed pleasure in photographing in mist or in the delicate drizzle of a spring shower.

Summer. This is the time associated with ripening and maturity, which trees exemplify in their rich green foliage and in the fullness of a forest

While shooting in Yosemite National Park in Wyoming, I positioned these pale aspen trees against the darker conifers to create contrast. The monochromatic tonalities, overexposed by 1/3 stop from the meter reading of the grays, keep the image simple and stark. With my Olympus OM-4 and my Zuiko 180mm telephoto lens, I exposed at f/11 for 1/125 sec. on Fujichrome 100 RD Professional film.

I shot this blooming cherry tree in New Jersey's Branch Brook Park from an upward perspective to create backlight. I brightened the pastel pink blossoms, via a 1/2-stop overexposure from a general meter reading. Working with my Olympus OM-4T and Zuiko 35mm medium-wide-angle lens, I exposed Fujichrome 100 RD Professional film for 1/125 sec. at f/11.

To convey the atmosphere of a hazy midsummer day in England's Lake District, I featured a full tree in the foreground and incorporated the surrounding landscape. I had to move down from the road to find just the right position since the background was quite bright and would have dominated the shot if I'd shot from a higher vantage point. I took a meter reading of the foreground for this high-contrast scene. With my Olympus OM-3 and my Zuiko 50-250mm zoom lens, I exposed at f/8 for 1/250 sec. on Kodachrome 64.

canopy. In order to add variety to so much lushness, you should shoot in early-morning mist or during the comings and goings of powerful summer storms. The dark skies and severe thunderclouds can make an otherwise placid scene appear dramatic. To provide a change of perspective in your images, be aware of reflections of trees in ponds and lakes, show trees in wide-open settings, or portray trees from below by looking up toward a clear blue sky.

Autumn. This is the time of reaping, when the year's efforts reward you with a bountiful harvest of images. Few photographers can resist the lure of fall foliage, its spectacular colors made even richer by the warm glow of low-angled sunlight. If you get up early enough, you may find mist along the water. Later in the day you can either shoot the foliage backlit against blue sky, or try your hand at closeups of leaves, fruits, and berries. Include the winding paths of a countryside road that invites viewers to follow its lead. Then take some telephoto shots along mountainsides, massing bare trees for texture or picking out a particularly well-formed tree shape for a silhouette.

To bring out these greens while shooting at Old Westbury Gardens in New York, I took advantage of the early-morning backlight, which illuminated the leaves and let the tree trunks provide a dark counterpoint. I metered the center of the frame and shot at this reading, using a Zuiko 100mm telephoto lens on my Olympus OM-4T to compress the trees. This massing resulted in increased contrast. The exposure was 1/30 sec. at f/16 on Fujichrome 50 RF film.

Winter. This is the time of hibernation, when nature braces itself against the cold, and trees endure in silence. Focus on the shapes of bare trees, their delicate branches defined against dark shadows or their silhouettes set off against snow. Show how these stalwart trees brave the harshness of the season, with snow and ice clinging to their branches. Another possibility is to reveal their tenacity within a forbidding landscape. Winter offers stark contrasts of black and white, which subtle traces of color occasionally punctuate. To truly capture the mood of the season, shoot these monochromatic scenes in overcast light.

EXTEND YOUR IMAGINATION

An unfettered, well-nourished imagination sees no end to photographic possibilities. If your creativity is ready to take flight, the following suggestions will help you lift off. Work toward building an emotional dimension into your images. The more closely you analyze your own reaction, the more clearly you'll identify what moved you and try to express that in your tree composition. Whether the source of your inspiration was the

Late-afternoon illumination enriches the oranges and golds of autumn foliage. For this scene, taken at The New York Botanical Garden, I metered the leaves at the top of the frame and underexposed by a full stop. This tight composition, shot with a Zuiko 100mm telephoto lens, condenses the scene, further saturating the colors. With my Olympus OM-4T, I exposed Kodachrome 25 for 1/8 sec. at f/16.

An abstract image came to mind when I saw the reflections of several tree trunks in a pond at the Middleton Garden in South Carolina. When the wind calmed down, I put a powerful Zuiko 300mm telephoto lens on my Olympus OM-4T to frame the colorful azaleas and bright trees. The exposure on Fujichrome 100 RD Professional film was 1/30 sec. at f/11.

With a little imagination, I saw the possibility for an interesting image that would combine aspen trees growing along a Colorado hillside with clouds in a bright blue sky. To create this tight abstraction from a distance of about 700 feet, I set my Zuiko 50-250mm zoom lens at 200mm. With my Olympus OM-4T, I exposed at f/8 for 1/125 sec. on Fujichrome 100 RD Professional film.

subject's color, abstract design, atmosphere, or mood, focus on the core emotion so that its concentrated energy dominates the final image.

Keep in mind that odd combinations can work wonders for getting you out of a visual rut. Try a bold approach by integrating pieces of a tree into the scene. Look for ways to disguise trees by emphasizing their texture and color rather than their readily recognizable shapes. Discover the power in reflections, shadows, and silhouettes by training your eye on elements beyond the trees themselves.

If you are ready for more, experiment with filters, unusual camera settings, and various films. For example, try shooting daylight-balanced film under incandescent lights at night. You can also try pushing film; shoot ISO 100 film at ISO 200, ISO 400, or even ISO 1600! If a single image doesn't capture what you want to express, try shooting double exposures. Another alternative is to combine two shots into a single "sandwich." Here, you place one slide on top of another. If the new image works, you can bring it to a custom lab for duplicating.

New challenges extend your imagination and help you discover images you never thought possible. As you develop your own aesthetic sense and gain confidence in your ability to see imaginatively, you'll want to use your camera equipment as a means toward actualizing that vision.

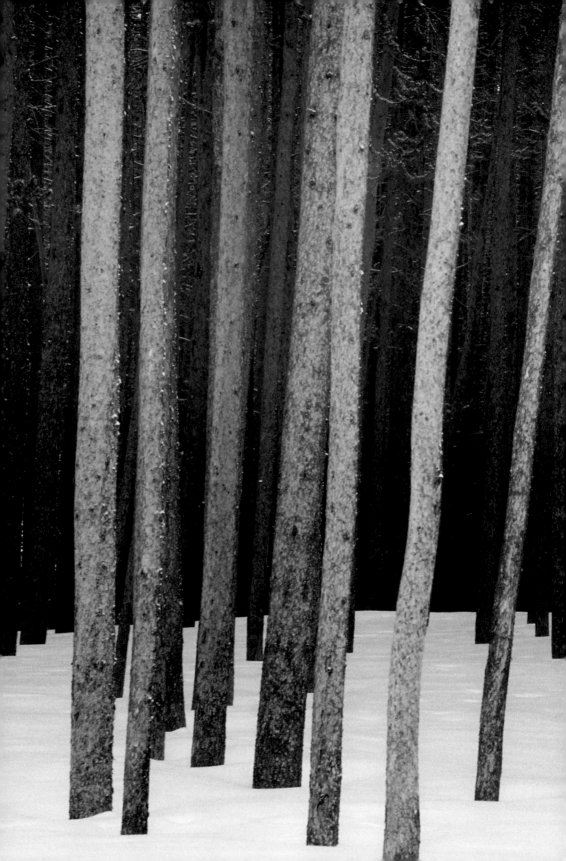

CHAPTER 2

Tooling Up

A telephoto lens makes this kind of photograph possible because it compresses and flattens space. For this shot, which I made in Yellowstone National Park, I used my Zuiko 300mm telephoto lens to push the tree trunks together and press them against the dark backdrop. As a result, they appear nearly two-dimensional. With my Olympus OM-4T, I exposed Fujichrome 100 RD Professional film for 1/30 sec. at f/11.

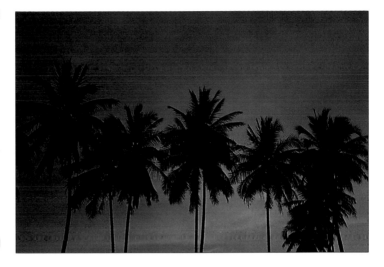

A tripod was essential to keep the camera steady for this low-light image. I photographed these palm trees along a beach in southern Thailand just before sunrise. With my camera mounted on a tripod, I was able to shoot at a slow shutter speed of 1/8 sec. while stopping down to f/11 to maximize depth of field; I wanted both the trees and the sky in sharp focus. Here, I used my Olympus IS-3 with its built-in Zuiko 35-180mm zoom lens and Ektachrome Elite EB film.

Now that your imagination has been fired up, you may be ready to start hunting for those "stop-in-your-track" subjects. But before you dash outside with your gear, you should take stock of the equipment you have. Remember, these are the tools that will enable you to transform the raw materials at hand into glorious visions on film. And as you go down the list of camera-equipment essentials, you'll learn how each item can help you achieve your photographic goal.

A sturdy 35mm SLR camera will perform well in all weather conditions if you take precautions. I shot this solitary pine tree in Yellowstone National Park as the temperature dropped to 20 degrees below zero. I kept my camera under my parka until I was ready to shoot. With my Olympus OM-3 and my Zuiko 50-250mm zoom lens, I exposed Kodachrome 64 at f/8 for 1/30 sec.

In this spring scene taken at The New York Botanical Garden, I added a polarizing filter to remove reflections from the foliage and flowers, so that the true greens and yellows would show through. With my Olympus OM-4T and Zuiko 35-70mm zoom lens, I exposed for 1/15 sec. at f/16 on Kodachrome 64.

Luckily, you won't need all kinds of fancy equipment to photograph trees. If you've been taking nature pictures all along, you probably own most of the gear you need. But if you haven't been photographing nature, rushing out to buy lots of new equipment before you know exactly the kinds of shots you want to take would certainly be a mistake. Instead, you should start simply and build on what you have as you continue to shoot. You can select new items as you realize their importance in terms of getting the images you want. When you do add to your collection of equipment, be sure to buy the best quality you can afford.

Still, you'll need some basics right away. Naturally, these include a camera, preferably one with interchangeable lenses or a built-in zoom lens to give you flexibility in composing. Today's sophisticated electronic cameras provide a wide range of options, and new models come out often in every price range. In addition to considering the main categories of cameras on the market discussed in this chapter, you should keep up with the latest offerings. Pick up a copy of a reputable photography magazine, such as *Popular Photography*, which often tests new cameras and other equipment and explains the results, usually with visual backup.

Before you get started, you need to think about the wide assortment of accessories available to you, from those you "can't do without" to those that are just good to have. Some, such as a sturdy tripod, are more important for tree photography than others. You also have to consider the growing number of films on the market. Their strengths and weaknesses vary, and their differences can be quite visible. So pay close attention to the type of film used for each shot throughout the book. This will give you a clear sense of how different films render color and respond to light. By the end of this chapter, you should have a better sense of what your "photographic toolbox" should contain, as well as how each item in it can help you create the kinds of tree images you can be proud of.

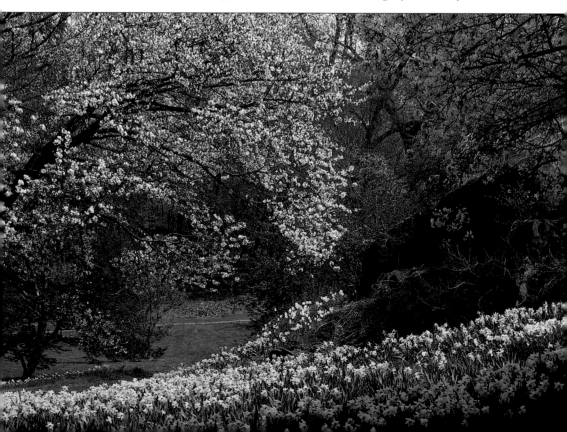

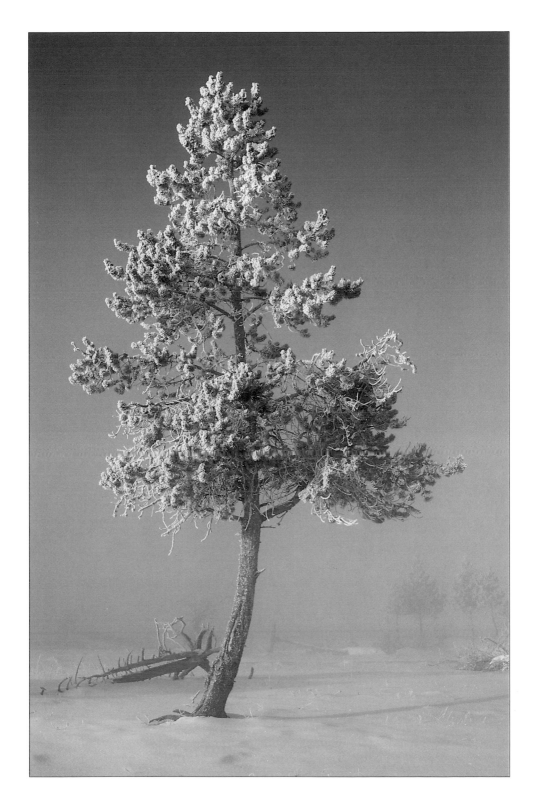

Even if you don't plan to take pictures, it is a good idea to carry along a small, light point-and-shoot camera in case you come across a worthy subject. While on an afternoon walk in New York's Westchester County, I noticed these blooming cherry trees. The built-in Zuiko 35–110mm zoom lens on my Olympus IS-1 let me home in on them to capture this quintessential spring scene. The exposure was 1/60 sec. at f/8 on Fujichrome 100 RD Professional film.

CAMERA BASICS

Unless you are in the market for a new camera, stick with the one you have until it no longer serves your needs. This way you can practice your skills before making a major investment and increase the likelihood getting new gear with the features you want. You can use any of the following types of cameras to shoot trees.

Single-lens-reflex cameras. The 35mm single-lens-reflex (SLR) camera is the one that many professional and most serious amateur photographers prefer. The main advantage of using an SLR is the degree of control it affords you. It lets you choose from a wide range of lenses for composition flexibility and makes it easy to add filters. It also enables you to fully control the technical and aesthetic aspects of your photographs, as long as you know what you're doing—and our goal is to provide you with that understanding by the end of this book.

If you're looking at new cameras, keep in mind that models with the latest in automatic and electronic wizardry aren't necessary for photographing trees. In fact, you'll probably find yourself overriding the autofocus feature more often than not when you shoot trees. So unless you want those features for other photography you plan to do, you don't need to pay a premium for them.

Point-and-shoot cameras. The greatest proliferation of new 35mm cameras in recent years has been in the so-called point-and-shoot category. These small, light cameras are remarkably versatile and accurate. This is especially true of those cameras with built-in zoom lenses, spot meters, and exposure-compensation features that give you some override capability in such complex situations as backlighting. But point-and-shoot cameras don't offer the kind of precise control you get with SLRs. Nevertheless, determined photographers can produce skillful results that

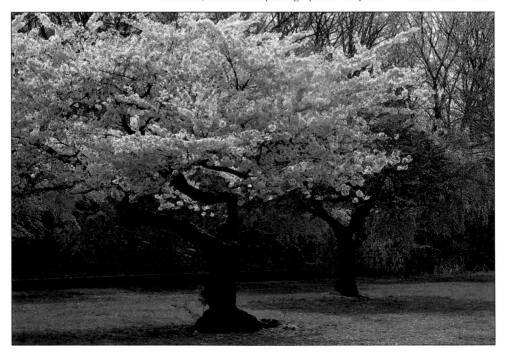

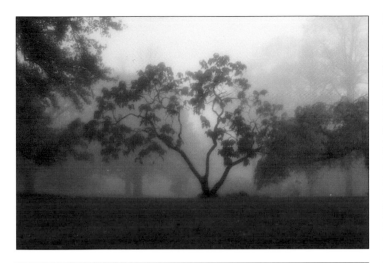

A 35mm SLR camera offers a wide variety of interchangeable lenses, opening up all sorts of creative possibilities to photographers. I couldn't have taken this shot without a long telephoto lens to flatten the planes and compress the space between the gingko and weeping cherry trees. I wanted to produce these effects in order to have the foreground lawn and the misty landscape appear stacked. I used my Olympus OM-3 and my Zuiko 180mm telephoto lens, and exposed for 1/30 sec. at f/11 on Kodachrome 64.

One of the key advantages of using a camera with manual controls is that you can override the indicated meter reading to fine-tune the exposure. For this picture of a crab apple tree that I came across in Holland, I wanted to deepen the red of the blooms. My Olympus OM-4T enabled me to meter through the lens and then underexpose by a full stop in order to saturate the color. Shooting with my Zuiko 50–250mm zoom lens, I exposed Fujichrome 100 RD film at f/11 for 1/30 sec.

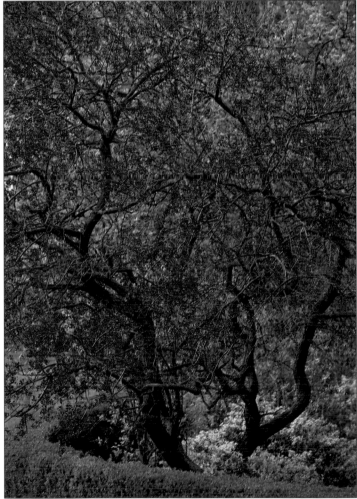

come close to those they achieve with SLR cameras. Be aware, however, that the menus and program modes of point-and-shoot models take some getting used to.

If a point-and-shoot model is the camera for you, try to get one with a wide zoom range. Some point-and-shoot cameras go from 28mm to 180mm. Also, if you want to shoot more distant subjects, you should consider models with attachments that extend the range even more to 300mm, such as the Olympus IS series.

Medium-format cameras. If you want sharpness, you may prefer this type of camera. The larger negatives, or transparencies, that a medium-format camera produces give you sharper, clearer images than a 35mm camera. Medium-format negatives come in three sizes: 6 x 6cm, which is a square format; 4.5 x 6cm, a rectangular format; and 6 x 7cm, a panoramic format. You can also alternate lenses, whose focal lengths range

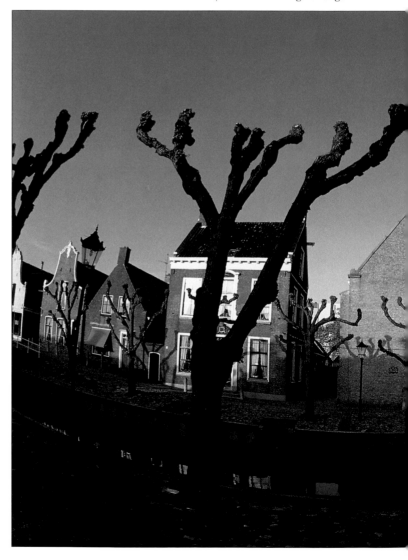

When I saw this row of knobby, severely pruned trees lining a street in Sloten, Holland, I decided to deliberately distort the eerie sight before me. I turned to my Zuiko 18mm ultrawide-angle lens. It gave me the perspective I wanted, exaggerated the foreground, and included some typical village houses in the background. With my Olympus OM-4T, I exposed Fujichrome 100 RD Professional film at f/16 for 1/30 sec.

from ultrawide-angle to telephoto, but these lenses are bulkier, heavier, and slower than lenses for 35mm cameras.

Many medium-format cameras have removable filmbacks, so you can easily switch from one kind of film to another when you are in the midst of shooting. Be aware, however, that fewer types of film are made for medium-format cameras. You should also keep in mind another potential drawback: in general, medium-format cameras, lenses, and accessories are more expensive than their 35mm counterparts.

LENSES

If you're working with a 35mm SLR camera, you can expand your visual options with an array of interchangeable lenses. (If you use a point-and-shoot camera, you'll find that these lens descriptions will give you a sense of what each focal length can do, which you can then apply to your camera's built-in zoom lens.) For photographing trees, you don't need to

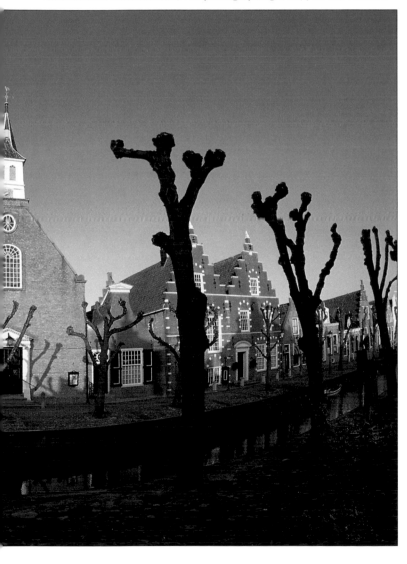

(Overleaf) My Zuiko 24mm wide-angle lens was ideal for framing this tall cherry tree while I looked upward. Shooting in New Jersey's Branch Brook Park, I composed so that the trunk wasn't in the center of the image. This approach minimized the distortion the lens produced. Then to add visual interest, I used a polarizer to deepen the blue of the sky. Shooting with my Olympus OM-4T, I exposed Fujichrome 100 RD Professional film for 1/15 sec. at f/16.

41

The fine lines of a willow tree's branches appealed to me as a silhouette set against a winter sky. Because I was working at a relatively short distance from my subject, I decided to use my Zuiko 21mm wide-angle lens to encompass the entire tree. This choice also enabled me to show the broad context of the surroundings without a loss of sharpness. In addition, the lens' tendency to distort the foreground creates an optical illusion: the branches seem more spread apart than they actually were. I think that this effect enhances the image. Here, I used my Olympus OM-3 and exposed Kodachrome 64 for 1/60 sec. at f/11.

To concentrate the colors of the blooms on this hillside planted with cherry trees at The New York Botanical Garden, I used my Zuiko 180mm telephoto lens. This lens visually pulls the entire scene forward and brings the various trees closer together, thereby creating the impression of density and rich color. Working with my Olympus OM-4T, I exposed at f/16 for 1/30 sec. on Fujichrome 100 RD Professional film.

spend a great deal of money on very fast lenses because you're working with stationary subjects. Furthermore, you are likely to be shooting with your camera mounted on a tripod and with your lens closed down to a small aperture.

Whether you're buying new lenses or using those you already own, base your choice of lens on the kind of image you want to create. Your vision for your tree photography will largely determine the way you plan to realize it. Keep the following factors in mind.

Standard lenses. A 50mm standard lens is often packaged with a 35mm camera body. This type of lens is inexpensive and produces a perspective that most closely resembles what the unaided human eye sees. A standard lens is fine for general panoramas, vignettes, and moderate closeups. But it can't provide the vertical reach of a wide-angle lens when it comes to shooting tall trees at relatively close range. So, if you're photographing in a forest where space is limited, you probably won't be satisfied with the scope of a standard lens. Standard lenses also don't have the capacity of telephoto lenses to magnify distant trees or compress space. If you shoot

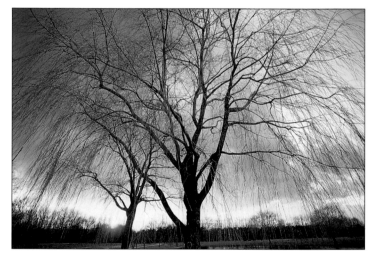

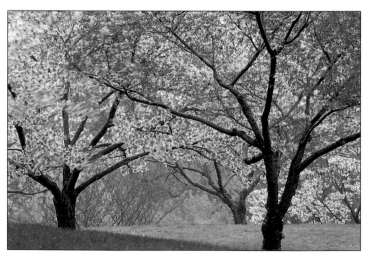

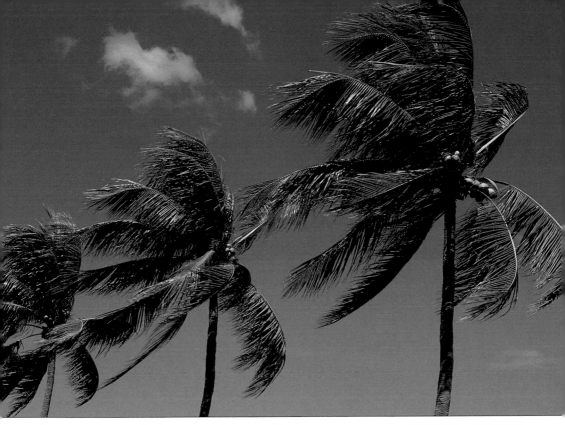

flowers or closeups of other nature subjects in addition to trees, you may want to invest in a 50mm macro lens instead.

Wide-angle lenses. In the 35mm format, any lens with a focal length shorter than 50mm is a wide-angle lens. All wide-angle lenses are useful for photographing trees. These lenses can encompass an entire tree at relatively close range, even while showing the broad context of its surroundings without a loss of sharpness. They are also good for framing tall trees from below, looking upward. But some distortion will be noticeable in these perspectives: the foreground will be exaggerated in size, and the background will be diminished. Be especially cautious about the effect on parallel lines, which will converge dramatically. This capacity to stretch out space, however, can increase the impression of depth between a nearby foreground tree and its setting.

Telephoto lenses. While this kind of lens is known to magnify distant subjects, its ability to compress space and isolate a portion of a scene is even more useful for photographing trees. When combined with a limited depth of field and a large aperture, a telephoto lens permits you to shoot a distant tree in such a way that it stands out against a blurred backdrop. This technique simultaneously separates the tree from its setting and retains a sense of the surrounding landscape.

Lenses with focal lengths that range between 80mm and 200mm are best for photographing trees. Some photographers, however, use longer lenses with focal lengths up to 500mm. The more magnification power a telephoto lens has, the harder it is to handle. Because long telephoto lenses are heavy and bulky, you should always use a tripod to keep them steady while you photograph.

Although a 50mm standard lens doesn't have the same capacity to magnify distant trees that a telephoto lens does, it is well suited for carefully composed vignettes. While photographing these palm trees in Malaysia, I turned to my Zuiko 50mm macro lens because I wanted to show only their upper portions. I felt that the beach scene below was too chaotic for my purposes. This lens also let me portray the series of receding trees as if they were actually decreasing in size, an illusion that intrigued me. Here, I used my Olympus OM-4T and exposed Ektachrome Lumière LPP film for 1/250 sec. at f/8.

Kodachrome 64, the grandparent of color-transparency film, still has an important place as a faster version of Kodachrome 25. Kodachrome 64 is particularly noted for its rich, warm tones, which is why I chose it to photograph this bright pink crab apple tree at The New York Botanical Garden. With my Olympus OM-3 and Zuiko 180mm telephoto lens, I exposed Kodachrome 64 for 1/60 sec. at f/8.

Zoom lenses. This type of lens gives you many of the compositional advantages of changing lenses without the inconvenience of carrying extra gear. A zoom lens can range in focal length from 28mm to 200mm or from 35mm to 350mm without appreciable loss of sharpness. One such lens can take the place of several regular lenses, making for a lighter load, which is a boon when you travel and when you plan to hike into an area to shoot.

FILMS

Even serious amateur photographers who devote lots of attention to the latest gear often overlook the importance of choosing the "right" film for a particular shot. In fact, the film you use can make a significant difference in the way your final image looks. When you select film, you should give some thought to the aesthetics of color, grain, and possible variations in film processing.

Because new films are being developed all the time, you should once again consult a reputable photography magazine to learn about and compare the many products on the market. More important, do your own tests before you invest in large quantities of film. Shoot a roll of any film you aren't familiar with, putting it through the gamut of situations you expect to encounter. Keep careful records about the lighting conditions and your camera settings as you shoot. Then study the results carefully. Better yet, take along two cameras loaded with different films, and shoot the same subjects. Comparing the results could be quite an eye-opener.

The real problem with selecting is that photographers have so many good options. In the broadest sense, however, your choice boils down to three categories of film: black-and-white-print film, color-print film, and color-transparency film. Within each category, films differ in the way they render color, contrast, and grain; in their responsiveness to light, which is indicated by their speed, or ISO rating; and in how they are

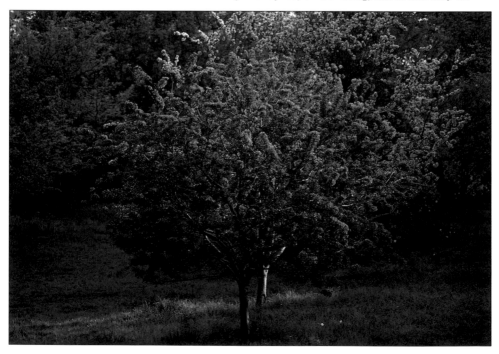

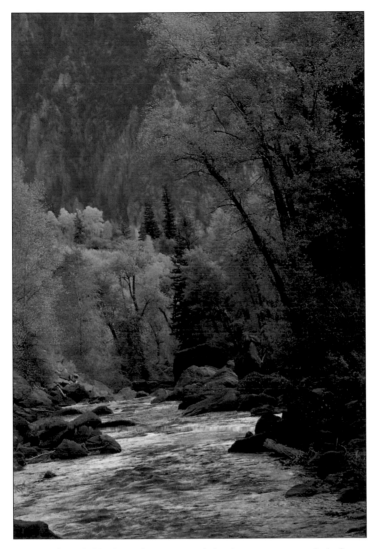

The low, predawn illumination along this Colorado river canyon demanded a film that could successfully handle such a challenging light condition. I turned to Fujichrome Velvia because I knew that it could bring out the greens of the cottonwood trees and the blues of the surroundings despite the dull, dim illumination. Working with my Olympus OM-4T and my Zuiko 50-250mm zoom lens, I exposed at f/5.6 for 1/60 sec.

processed. Each film has advantages and disadvantages, particularly for nature photography. But ultimately your decision will depend on your aesthetic vision and what you plan to do with your photographs. Here is a brief rundown of the factors to consider.

Black-and-white-print film. Kodak T-Max 100 film has very fine grain and good contrast, characteristics that produce extremely sharp, snappy prints. These qualities make this an excellent black-and-white-print film for purely graphic portrayals of trees. Kodak Plus-X film, rated ISO 125, is slightly less contrasty than T-Max 100, but almost as sharp. Because Plus-X has an extensive range of tonalities, it is an excellent choice whenever middle tones are important to your images. Kodak Tri-X 400 film is a faster version of Plus-X, though a bit grainier, less sharp, and more contrasty. Its fast speed makes it a good option if you must handhold your camera while it is set for a small aperture. For an interesting grainy look, push Tri-X to ISO 1600 or 3200.

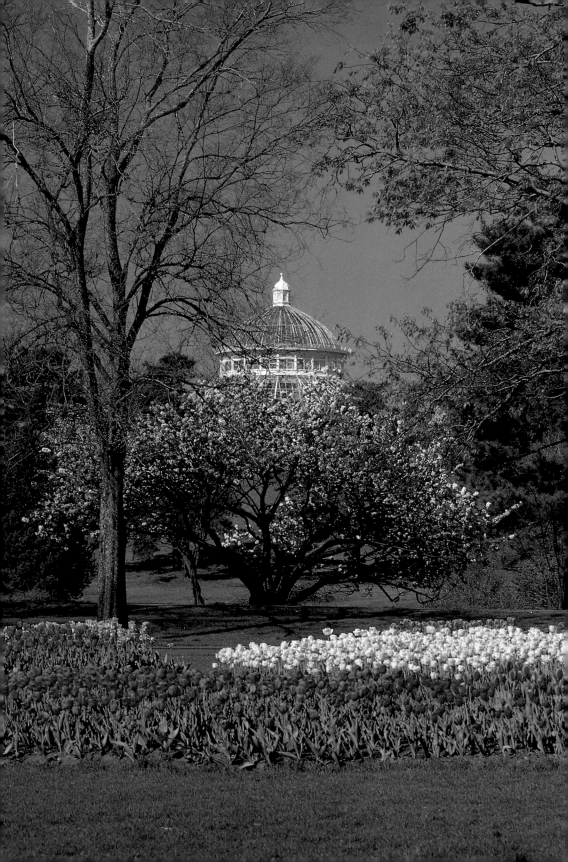

While shooting a poster of The New York Botanical Garden, I composed the picture so that it incorporates the most distinctive feature: the glass dome of the conservatory, which is framed by trees and introduced by flowers. In order to get the sharpest possible image throughout the frame, I chose Kodachrome 25. The film also enriched the vibrant colors of the tulip bed while it maintained the integrity of the trees and sky. Here, I used my Olympus OM-3 and Zuiko 100mm telephoto lens, and exposed at f/16 for 1/30 sec.

I made this backlit shot of an aspen grove in Colorado with Ektachrome 64 EPZ film. I selected this film for its fine grain and beautiful rendering of warm colors, such as the yellows and earth tones in this image. This film also enhanced the light from the sunset in this late-fall scene. Shooting with my Olympus IS-3 and its built-in Zuiko 35-180mm zoom lens, I exposed for 1/15 sec. at f/11.

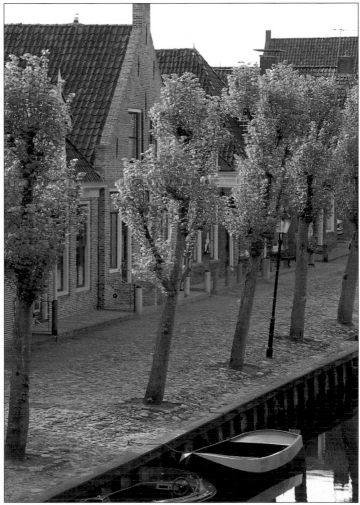

The sun had already set behind the Dutch village of Sloten, so I needed a contrasty film to add punch to these trees. Because I used Fujichrome Velvia, the greens didn't merge with their gray surroundings. Instead, they helped define the trunks for a strong graphic effect. With my Olympus OM-4T and my Zuiko 50-250mm zoom lens, I exposed at f/16 for 1/30 sec.

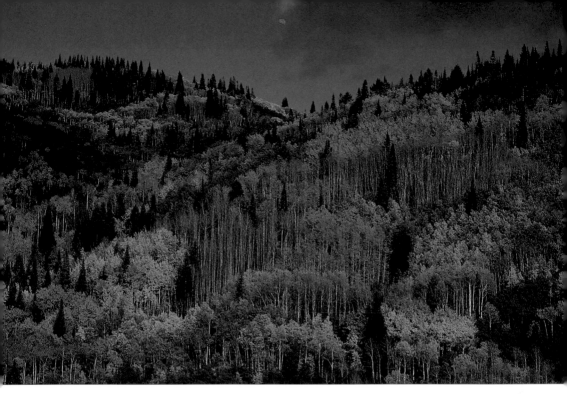

I used Fujichrome Provia 100 for this autumn display of aspen and evergreen trees in Colorado because of its fine grain and sharpness. This film also rendered the delicate palette well and made the blue sky vibrant. Working with my Olympus IS-3 and its built-in Zuiko 35-180mm zoom lens, I exposed at f/8 for 1/60 sec.

Color-print film. This kind of film is intended for photographers who prefer to display their work in albums, although it is also suitable for fine prints that will hang on a wall. Color-print, or color-negative, film is also now commonly used for newspaper reproduction; however, it isn't the film of choice for reproduction in books or magazines. Color-negative film is easier to expose than color-transparency film because it is more tolerant of contrasty lighting situations. If you bracket when shooting this film, bracket toward overexposure, not underexposure. An overexposed negative is easier to print than an underexposed one.

We find Kodacolor Gold and Fujichrome Reala 100 to be the best choices for tree photography. Both are fine-grained films that produce rich, vivid colors. Fujichrome Reala has snappy cool greens and blues, while Kodacolor Gold favors warm reds, yellows, oranges, and browns.

Color-transparency film. If rich colors and sharpness are important to you, you should opt to shoot color-transparency, or color-slide, film. Professional photographers use slide film for most editorial photography, the kind you see, for example, in nature magazines. Processing costs per roll of color-slide film are less expensive than those of color-print film, and you can easily produce an enlarged print to frame from a transparency.

Films within this category vary considerably from one another:
■ **Fujichrome Provia and Sensia 100** produce vibrant greens and blues and effectively render pastels in the cool hues. They have fine grain for sharpness, can be successfully pushed to ISO 200, and requires E-6 processing, which can be done in a few hours.
■ **Fujichrome Velvia,** which professional photographers favor, offers brilliant colors and fine grain; it is also able to handle low-light and low-contrast conditions well. And although Velvia is a slow film, rated ISO 40, you can effectively push it to ISO 100. Keep in mind, however, that it is

a contrasty film and tends to overexpose. So, it is a poor choice for photographing with point-and-shoot cameras.

■ **Ektachrome Lumière**, rated ISO 100, is an excellent new Kodak film that compares favorably with Fujichrome films. It is less contrasty than Provia 100, but it is as fine-grained as Velvia. And like these two Fuji films, Lumière uses E-6 processing.

■ **Ektachrome 64 Professional EPX** film is a fine-grained film that renders warm colors beautifully and produces a cool blue tone in sky, water, and mist areas of images. It is an excellent film to enhance sunsets and fall foliage: it does wonders with yellows and earth tones, and renders greens in a more muted—some people say more natural—way than Fujichrome films do. Ektachrome 64 Professional EPX film, does, however, tend to underexpose easily, so you should take careful meter readings and bracket liberally.

■ **Kodachrome 25** is the slowest, most fine-grained film in this category. Many photographers favor it for its rich color saturation, especially its warm, vibrant reds, and its rendering of warm-tone pastels. Kodachrome 25 requires special processing, so it isn't recommended for photographers who use point-and-shoot cameras.

While photographing sculpture at the Storm King Art Center in New York, I took some time to record the early signs of autumn (left). With my Olympus IS-3 and its built-in 35–180mm zoom lens, I exposed this scene for 1/15 sec. at f/8 on Ektachrome EPZ. Only a few trees' leaves had turned, however, so I added an 85 warming filter for another shot (below). I knew that it would give the scene more of a fall feeling. Working with the same camera, lens, and film, I exposed this image for 1/30 sec. at f/8.

FILTERS

Filters can give you the creative edge you want in your nature photography, particularly when you're shooting trees. These screw-on glass filters enhance your image in a variety of ways. Because they are small and light, you can carry them with you at all times and experiment freely with the effects they produce. When you are ready to buy filters, you should start building your collection with the following assortment.

Polarizing filters. These rotating filters help remove reflections from foliage, so its true, natural colors show through. Polarizing filters, or polarizers, can also deepen the blue of the sky and whiten clouds, thereby increasing their color contrast with trees. As you rotate the filter and watch its effect through the lens, you can control the amount of polarization. Unfortunately, polarizers aren't available for most point-and-shoot cameras, and some of the new autofocus SLRs require a special polarizer that works on a circular rather than a linear pattern. Check before you buy.

Warming filters. These sepia-tone filters can boost the golds, oranges, and yellows of fall foliage. The filters can also increase the impact of sunset light and warm the cool light in a forest setting. They come in two series, 81 and 85, and vary in intensity. Their strengths are indicated by the letters "A," "B," and "C"; the higher the letter, the deeper the color of the filter.

Skylight filters. Protect all your lenses from dust, scratches, and abrasions with a 1A or 1B skylight filter or an 81A warming filter. Keep in mind, though, that these filters also give a slightly pink cast to your image, warming a scene and counteracting atmospheric blues. If you like the warming effect, try the KR red 1.5 filter, which intensifies green foliage.

Soft-focus filters. As their name implies, these filters have a diffusing effect that softens images. Such a misty, romantic aura can be particularly appealing if you're shooting flowering trees in the spring or warm colors in the fall. The exact amount of diffusion depends on the specific filter. You can simulate the effect by slipping a silk stocking over your lens or by using a diffusion or fog filter. And in a pinch, breathe on your lens, and work quickly to retain the foggy effect.

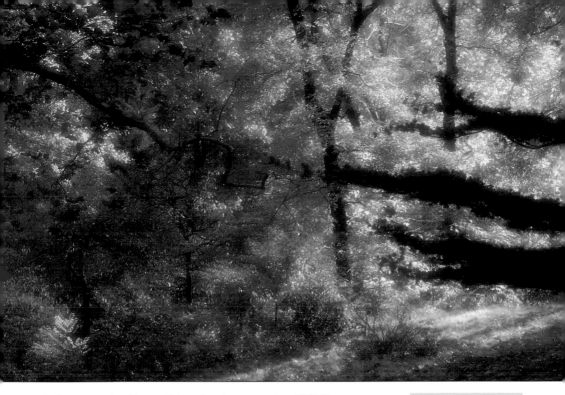

Color-correction filters. Although color-correction (CC) filters are designed to increase or decrease contrast in black-and-white photographs, they have their place in color photography as well. Some photographers use them to enhance a specific color in an image. For example, a yellow filter intensifies autumn foliage, while a green filter boosts the colors of spring and summer leaves. However, unless your aim is to create a surreal special effect, you should use these filters judiciously. Avoid unnatural-looking subjects by working with the least intense filter in the color family, and by checking that the color doesn't dominate or distort other hues in your image.

OTHER ESSENTIAL GEAR

There is no end of gadgets, paraphernalia, and accessories to tempt determined nature photographers. The following discussion indicates, in order of priority, the most essential and useful ones to invest in.

Tripod. A sturdy, stable tripod is the most critical accessory for tree photography. Well-made tripods, such as those manufactured by Bogen and Gitzo, let you compose carefully and precisely, as well as maintain any position, no matter how awkward, through any number of exposures. Without having to worry about a steady hand, you can use slow shutter speeds and small aperture settings in order to achieve extensive depth of field and maximum sharpness.

Ball-joint head. A ball-joint head that maneuvers easily and locks with a single turn makes using a tripod much less bothersome. The Bogen, Foba, and Linhof Profi models are excellent.

Handheld spot meter. A handheld spot meter, such as the Minolta Spotmeter F, is a wonderful aid for pinpointing exposure readings,

In the early days of my career, I wasn't able to afford a complete set of filters. So I wrapped pairs of cut-up pantyhose over my lenses, securing these filter substitutes with a rubber band, to produce a softening effect. To this day, sometimes I still prefer that look to the ones my standard filters create. I've learned that this alternative works best with telephoto lenses. I used this approach to achieve this abstract portrait of autumn foliage while working at The New York Botanical Garden, which I made with my Olympus OM-4 and my Zuiko 100mm telephoto lens. The exposure on Kodachrome 64 was f/11 for 1/250 sec.

I needed a handheld spot meter to fine-tune the exposure for this shot, which I took at Kentucky's Bernheim Forest. Without that meter reading, I might have underexposed both the tree and the ridge behind it, losing the detail I wanted and muddying the delicate light in the mist. Shooting with my Hasselblad CM and a 150mm lens, I exposed at f/11 for 1/15 sec. on Fujichrome 100 RDP Professional film.

especially if you're shooting trees at a fair distance under variable- or high-contrast lighting conditions. This kind of meter is also a good backup for checking the accuracy of your camera's built-in light meter.

Lens shade. A lens shade prevents extraneous rays of the sun, which cause flare or glare, from entering the camera. Buy the deepest lens shade available for each lens. The wrong size lens shade may cause vignetting, which is a darkening in the corners of the frame where the lens shade is visible. Look for possible vignetting whenever you use a wide-angle lens or zoom lens, or if the lens shade is mounted on a filter. A thick, collapsible rubber shade also protects your lens from rain, snow, and fingerprints, and from accidental damage that a bump or fall may cause.

Camera bag. A suitable camera bag is a must. Your bag should be stable, strong, and light, with enough space to comfortably and firmly hold your gear in separate compartments. A bag that is too large may let equipment bounce around, while one that is too small may let some pieces of equipment fall out. Snap-together closure devices are more reliable than zippers and snaps. Check the Tamrac and LowePro AW models.

In addition to a camera bag, some photographers like the convenience of a photo vest or a belly pack. These come in handy if you plan to hike a distance to your destination and don't expect to carry much gear. But they aren't adequate substitutes for a good camera bag.

Camera strap. When you photograph trees, you should have your camera on a tripod whenever possible. A comfortable camera strap is only a must if you plan to wear your camera over your neck for any length of time. The strap should be wide enough to rest easily around your neck without cutting or chafing. And be sure the strap is made of a high-grade material that won't unravel after only a few uses.

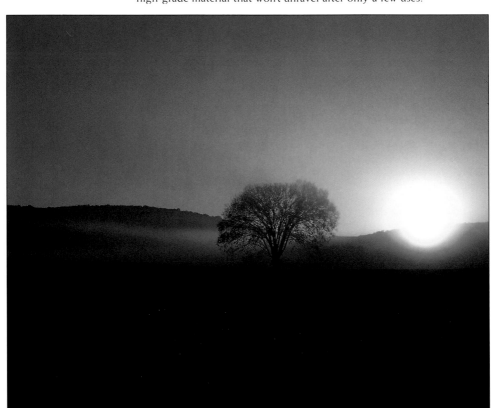

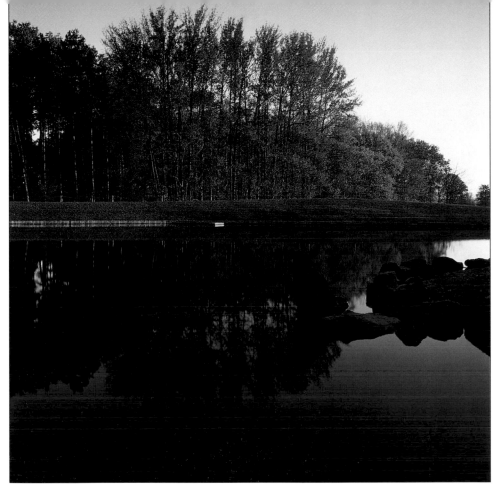

Cleaning kit. Check your gear, and clean it thoroughly right after each shoot. That way, surface dirt won't have a chance to settle in and cause serious or expensive damage. A small cleaning kit should include a soft cloth, lens tissue, and a bulb-type blower with a brush. Use the appropriate item to gently remove moisture and surface grime from your camera and lenses. For stubborn smudges, breathe on your lens before wiping it with lens tissue. Don't use these accessories to clean the inside of your camera—have a professional do that.

Closeup equipment. For shooting details of trees, you may want to have some closeup equipment on hand. You have three choices. A macro lens that is especially designed for closeups, is self-contained, is easy to use, and doesn't reduce light intake. This, however, is the most expensive option. Another possibility is a set of extension tubes. Although these are cheaper, putting them on is a bit time-consuming. And perhaps more important, they limit the camera-to-subject distance. Finally, you can opt for closeup screw-on lenses, which are the most economical choice. You can combine these for increased magnification, but they are the least sharp and must be used within a very limited working distance.

Cable release. This device lets you depress the shutter without touching the camera. This, in turn, reduces camera shake, especially during long exposures.

The setting sun was sinking quickly when I came upon this lovely scene of trees reflected in a pond in the Dawes Arboretum in Ohio. The ball-joint head on my tripod allowed me to maneuver my camera quickly, so I was able to set up the shot I wanted before I lost the light completely. I also used a split neutral-density filter to brighten the reflection, which was much darker than it appears. Working with my Hasselblad CM and a 60mm lens, I exposed Fujichrome Velvia for 1/8 sec. at f/22.

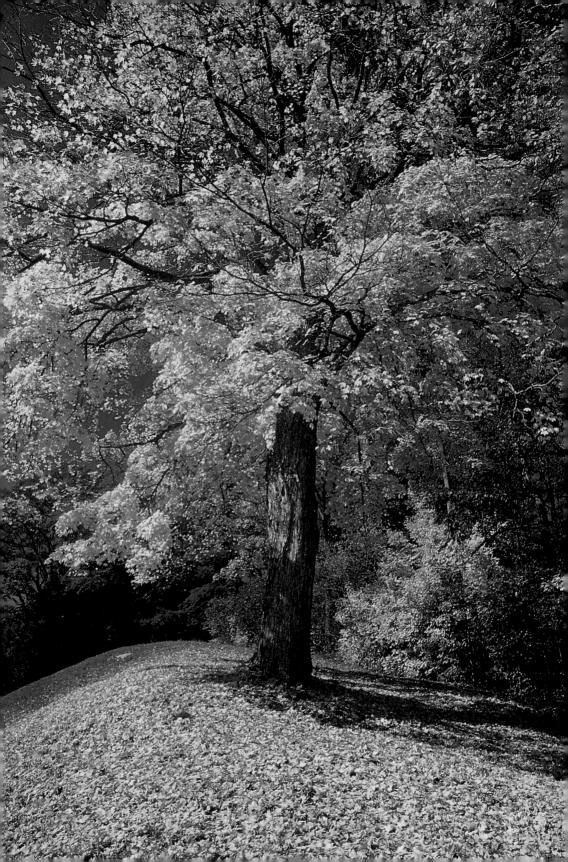

Working with Natural Light

The low-angled frontlight of a late afternoon during the fall seemed to strike this maple tree in a Westchester, New York, county park like a strong spotlight. To keep the yellows relatively soft and to suffuse the scene with a warm glow, I metered the bright leaves and shot at the indicated reading. Working with my Olympus OM-4T and my Zuiko 35mm medium-wide-angle lens, I exposed Fujichrome 100 RD Professional film at f/8 for 1/250 sec.

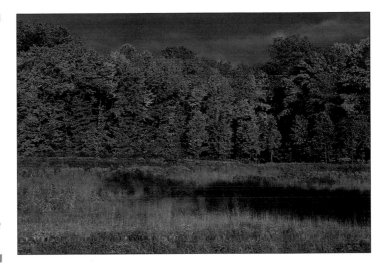

I watched as approaching thunderclouds loomed over a New Jersey meadow where I was photographing. An opening in the clouds cast a strong shaft of late-day sidelight on this scene, creating a contrast between these two kinds of illumination. I took advantage of the contrast to give the scene a dramatic luminosity, as well as to bring out the textures and colors of the trees behind the meadow. With my Olympus OM-4T and my Zuiko 50-250 zoom lens, I exposed for 1/30 sec. at f/16 on Fujichrome 100 RD Professional film.

Trees, like people, have distinctive physical characteristics. Some are tall and lithe, while others are squat and sturdy. Some are draped with feathery fronds, others are clothed in leaves as thick as leather, still others are arrayed in fine needles and, at the right time of year, many are stark naked. Beyond the various physical features of trees, they have changing moods. They can appear soft and romantic or tough and menacing at different times.

Bright overhead light caused a great deal of reflection to bounce off the foliage of the trees and the water in this lagoon in Thailand. To cut the glare and bring out the natural colors, I used a polarizer and underexposed by 1/2 stop from a center-weighted meter reading. I didn't underexpose the scene more because I wanted to retain detail in the shadows and brightness on the tall tree rising above the nearby mangroves. With my Olympus OM-4T and Zuiko 35-70mm zoom lens, I pushed Fujichrome 100 RD Professional film one stop, exposing at f/5.6 for 1/250 sec.

The element of light shapes these personality traits of trees. Like subtly applied makeup, light works its magic, making an ordinary tree look beautiful and a lovely tree look stunning. Light can bring out the strengths in a tree's form, color, and texture. It can also hide weaknesses by leaving them in shadow or diverting the viewer's attention elsewhere. In every season, in all kinds of weather, and throughout the day, natural light invites perceptive nature photographers to discover the ever-changing faces of trees.

But unlike both makeup and artificial studio light, you can't manipulate natural light to suit your needs. Nature photographers must make the most of the raw material at hand, creating evocative images with whatever light is available. So, you must learn to become attuned to the special qualities of every kind of illumination, developing an affinity for each. For example, you must come to appreciate the differences between bright sunlight and the muted light of an overcast day, and to understand how to use them to your advantage. You also need to notice how a change in the direction of the light can dramatically affect an image, and then remember to position yourself accordingly.

As you gain experience, you'll see how, whatever a tree's basic nature, its personality and appearance vary at different times of the day as the light changes, as well as in different kinds of weather. So, you must determine to be on location at the right times. You also have to develop the habit of returning to favorite tree subjects not only at midday, but also at sunrise and sunset; and not only in bright light, but also under a range of atmospheric conditions. In this way, you focus on creating images of trees that make the most of every kind of illumination, based on its direction, intensity, and color.

BRIGHT SUNLIGHT

Most novice nature photographers prefer shooting on bright, sunny days. This is, of course, easy to understand since most people enjoy being out-

doors in the sunshine. Photographically, however, these shooting conditions don't always provide the most flattering illumination to work with. On bright, sunny days, the available light tends to be harsh and contrasty, casting very deep shadows within the frame. Can you make this difficult light work for you? Absolutely—if you take some precautions.

First, you should shoot at the extremes of the day. Bright light is warm and dramatic early in the morning or late in the afternoon, when it isn't straight overhead. This low-angled illumination also permits you to explore the various directions of light. Simply move around as you work, changing your perspective on your subject.

Notice how each shooting position affects the way the tree is lit. Straightforward frontlight hits your subject head-on, backlight hits it from behind, and sidelight strikes your subject at a 90-degree angle to the lens. Backlight filtering through leaves enhances colors and makes them glow, while sidelight can spotlight a tree against an unlit background or shadow.

You should also underexpose your subject in order to saturate its colors. Bright sunlight tends to cast dark shadows throughout a scene, especially in the middle of the day. An averaging light meter handles these dark areas by leaning toward overexposure. Quite often the final image has pale, washed-out foliage. The simplest way to avoid this effect is to isolate and meter the brightest part of the tree; this yields an exposure reading that automatically deepens colors. For the best results, use a spot meter or the spot-meter setting on your camera's built-in meter.

Another option is to use your longest telephoto lens in order to isolate a bright area. If that isn't possible, frame your shot so that the bright section of the subject is in the middle of the picture. Next, take a center-weighted meter reading, and lock it in before recomposing the scene. If you're shooting a vista that incorporates trees, underexpose from a general meter reading by 1/2-stop intervals up to 1½ stops. In this situation,

The beaches of Grand Cayman can be so bright that many amateur photographs appear bleached and colorless. To prevent this possibility, I underexposed by one full stop from a meter reading on the foliage of this eucalyptus tree. This approach deepened the color of the sky and the strip of water visible at the bottom of the frame. Working with my Olympus OM-4T and my Zuiko 35-70mm zoom lens, I exposed Fujichrome 100 RD Professional film for 1/500 sec. at f/4.

I took this shot of a cotton-
wood tree framing the
famous Cathedral Rock for-
mation outside Sedona,
Arizona, in the late after-
noon with the sun at the 4
o'clock position (left). I
used a polarizer to deepen
the blue of the sky and to
increase the contrast
between the tree and the
sky. With my Olympus
OM-4T and my Zuiko
35mm medium-wide-angle
lens, I exposed Fujichrome
Velvia for 1/15 sec. at
f/16. I returned the next
morning to shoot the same
subject in a different light-
ing condition (right). When
I arrived, the sun hadn't
risen yet but was brighten-
ing the sky behind the rock
formation. By metering the
sky at the top of the frame
and shooting at the meter
reading, I recorded a sil-
houette. Using the same
camera, lens, and film, I
exposed this scene for
1/18 sec. at f/16.

you should bracket more at midday and less toward the beginning and
the end of the day.

Another precaution you should take when shooting in bright sunlight
involves a polarizing filter, or polarizer. This type of illumination pro-
duces spots of glare and reflections on the landscape, on water, and espe-
cially on foliage, turning greens an unappealing gray. A polarizer reduces
the glare and removes unwanted reflections, so the true colors of a tree's
foliage record in your image. A polarizer can also deepen the blue of the
sky, giving trees a bold backdrop on a sunny day. Rotate the polarizer as
you look through the lens until you see the exact effect you want.

BACKLIGHT

The most dramatic direction for natural sunlight is backlight, with the
sun facing the lens from behind a tree. Backlight is available throughout
the day as long as you position yourself so that the light penetrates the
leaves from behind. Whether you're shooting straight ahead at a low-
angled sun or upward toward an overhead sun, backlight creates a won-
drous stained glass effect on foliage. This kind of illumination also makes
colors shimmer, defines shapes clearly, and can create a celestial mood.

But the best backlight, which is relatively soft and evocative, is pre-
sent early in the morning and late in the afternoon. And it is worthwhile
to find and be in the right place at the right time. Of course, these mag-
nificent possibilities don't come easily. Here are some pointers to increase
your chances of success:

■ **Meter with care**. Backlight makes exposure tricky. The most common
mistake photographers make is metering the sky or the bright area
around the tree. This tends to underexpose the main subject. Instead, iso-
late the area of brightest color, and meter it without including any sun or
bright sky. Whenever possible, home in on the area you want to measure
for exposure with a spot meter, a center-weighted meter, or a long lens.

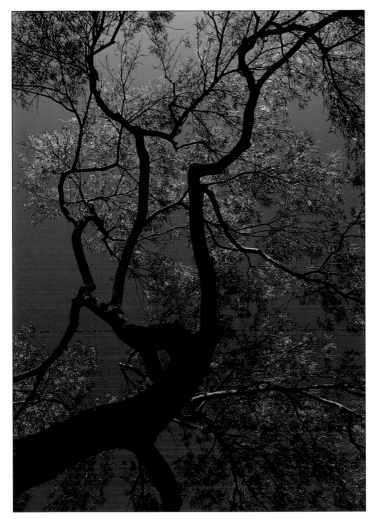

Use a lens shade, and always check that the sun's rays aren't entering the lens, thereby fooling the meter or causing flare.

■ **Overexpose darker areas for detail**. If you're shooting upward, you may not be able to avoid metering the sky. In this situation, overexpose from the meter reading to brighten the foliage, as well as to bring out color and detail on the side of the subject facing the camera—unless you want a silhouette. With backlight, the areas facing you are essentially in shadow and won't be visible if the illumination is very bright. You can overexpose a bit, up to 1½ stops, to keep these darker areas from registering as undifferentiated shadows. Be sure to bracket carefully, so you get the exact results you want.

■ **Shoot a silhouette**. If your meter reading shows a difference of three or more stops between the tree and the sky, you may prefer creating a deliberate silhouette. Here, you record the tree as a flat, black object against the sky. Silhouettes are effective when the trees have interesting lines or shapes and when the sky is particularly colorful. Simply meter the sky, and shoot at the indicated reading. A polarizer generally isn't necessary or helpful for shooting silhouettes.

Backlight works wonders as it passes through foliage. To make this Japanese maple at The New York Botanical Garden appear translucent, I metered the sky through a polarizer on my Zuiko 24mm wide-angle lens and overexposed by 1/2 stop to brighten the leaves. Shooting with my Olympus OM-4, I exposed Kodachrome 64 for 1/60 sec. at f/16.

(Overleaf, top) As soon as the morning sun rose over the ridge in the Colorado Rockies, I saw how the soft backlight played on the tips of the aspen trees growing on the mountain-side. To emphasize their feathery textures, I decided to create a tight composition that would contrast light and shadow, as well as gray tones and brilliant color. I metered the shadows and underexposed by 1/2 stop to saturate the bright foliage. I made this shot with my Olympus IS-3 and its built-in Zuiko 35-180mm zoom lens. The exposure was 1/125 sec. at f/8 on Fujichrome 100 RD Professional film.

(Overleaf, bottom) A halo of backlight defines this shapely poplar at The New York Botanical Garden and adds luminosity to the leaves of a nearby maple tree. I juxtaposed the two trees in this composition so that the light complements both and underexposed by one full stop from a meter reading of the poplar in order to enrich the foliage colors. Working with my Olympus OM-4T and my Zuiko 100mm telephoto lens, I exposed Koda-chrome 64 for 1/125 sec. at f/8.

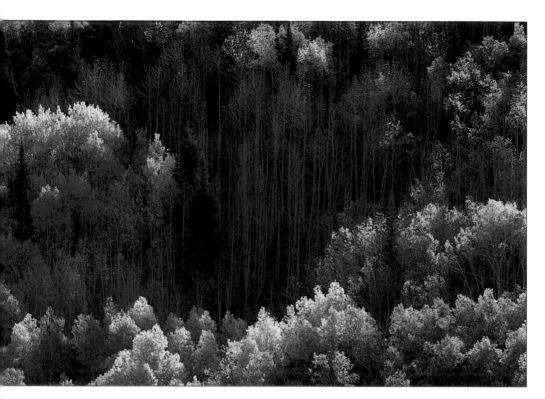

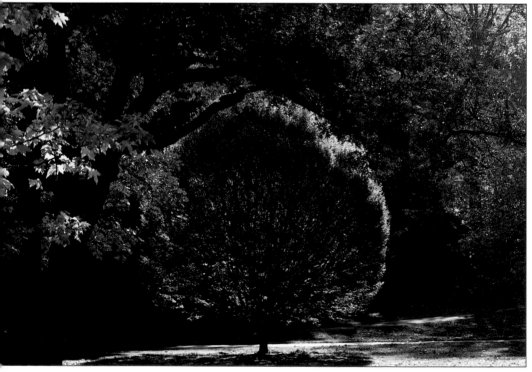

SUNRISE AND SUNSET

By now, you've gathered that, like many other experienced nature photographers, we prefer the light at the extremes of the day. And what could be more extreme than the light of sunrise and sunset? Actually, it is more complicated than that. Even before the sun comes up and after the sun goes down, a sensitive eye sees new possibilities every few moments as the light continually changes.

At these times of the day, trees may be your intended subject, but they actually play supporting roles to the true star and scene stealer: the light in the sky. As a result, you should concentrate on finding trees that record well as silhouettes. If possible, include other elements of the scene, such as a body of water, a farmhouse, or a bridge.

Once you've selected the trees and framed your shot, you should focus all of your concentration on capturing the richest colors in the sky. Don't use filters when you shoot at sunrise or sunset. They tend to dilute the natural colors in the scene.

This sunset shot looks much brighter than the scene actually was. The sun was setting behind the wall on the opposite bank of this Dutch canal, but it was rather low and dim. Nevertheless, I wanted to create an image that combined the mist with both the trees along the embankment and their reflection in the foreground. After mounting my Olympus OM-4T and Zuiko 35-70mm zoom lens on a tripod, I crouched down to lower the sun in the scene and to frame the exact shot I wanted. I overexposed the suggested meter reading by a stop to whiten the mist and brighten the reflection. The exposure was 1/2 sec. at f/16 on Fujichrome Velvia.

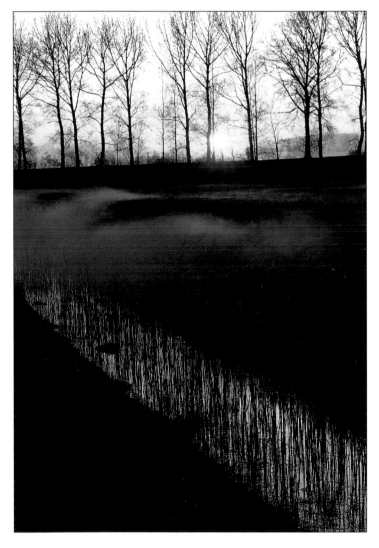

I watched as the disc of
the setting sun sank toward
the horizon, appearing to
come very close to this soli-
tary tree in a field in
Thailand. I needed to
maneuver quickly to get to
just the right spot and set
up in time to capture this
scene. The haze kept the
sun red and the sky a soft
pink, which provided a
pleasing backdrop for the
silhouetted tree. I took a
meter reading of the most
neutral-gray part of the sky,
which is about halfway up
the frame, and shot at that
suggested reading. With
my Olympus OM-4T and
my Zuiko 50-250mm zoom
lens, I exposed Ektachrome
64 EPX film for 1/15 sec.
at f/8.

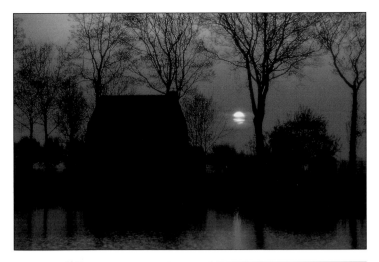

I wanted to capture this setting sun and its reflection on Holland's River Vecht. I found just the right spot, where the sun passed behind the trees of a nearby farmhouse. My purpose was to silhouette the scene and enhance it with sunset colors. I metered the sun's reflection and overexposed by 2/3 stop to both maintain detail in the reflection and soften the colors of the sky. Shooting with my Olympus OM-4T and Zuiko 50-250mm zoom lens, I exposed at f/8 for 1/4 sec. on Fujichrome Velvia.

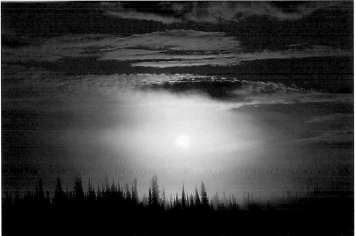

The forest of evergreens along the ridge infused sunrise at Alaska's Denali National Park with an extra touch of drama. The trees provide an interesting textural counterpoint to the glorious fireworks overhead, as well as give the sunrise a frame of reference. To maintain detail in the cloud formations, I took a spot-meter reading of the sky just over the horizon but away from the sun itself, and then bracketed toward underexposure. I made this shot at one full stop under the meter reading. Here, I used my Olympus OM-4T, my Zuiko 50-250mm zoom lens, and Ektachrome Lumière LPP film, and exposed for 1/500 sec. at f/5.6.

If the sun is visible right after sunrise or before sunset, you can maintain the intense colors in the scene by metering the dark part of the sky, not the sun itself. Next, bracket up and down at 1/2-stop intervals, up to a full stop in either direction. This step will enable you to choose the best exposure among your results. If the sun is below the horizon, meter the sky first and then bracket. Decrease the exposure by a stop to deepen colors, or increase the exposure at 1/2-stop intervals, up to 1½ stops, to brighten them. And keep shooting to show the ongoing change in the relationship of the sun to the silhouetted trees.

CONTRASTING LIGHT

A more complicated situation arises when the difference in the meter readings of highlights and shadows is two or more stops. Such contrasting light conditions pose difficulties in terms of accurate metering and achieving good exposure throughout the frame. The first step in handling such a dilemma is to recognize a high-contrast situation when it occurs. The only way that you'll be able to weigh your options and make the necessary decisions is by being aware of that the problem exists. Here are some suggestions to help you navigate these complexities.

My priority when shooting this scene was to keep the white brachts of the flowering dogwood tree as pure as possible. To spotlight them, I switched to a shooting position that placed the tree against a dark shadow area. I then took a spot-meter reading of the tree and overexposed by 2/3 stop to keep the white from turning a dull gray. The overexposure didn't significantly brighten the shadow area, but it made the greens more vibrant on this overcast day in Westchester County, New York With my Olympus OM-4T and my Zuiko 35–70mm zoom lens, I exposed for 1/60 sec. at f/8 on Fujichrome 100 RD Professional film.

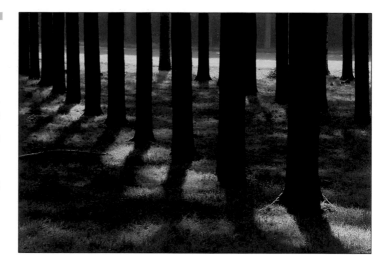

When I saw this forest in Holland, I decided to record an image that showed both its precision and its beauty. I chose a row of trees and shot it at a diagonal, using the contrast between the shadows in the woods and the strong sun filtering through to strengthen my graphic portrayal. Finally, I metered the shadow area and underexposed by 2/3 stop to make the entire image darker than it actually was. Here, I used my Olympus OM-4T and my Zuiko 50-250mm zoom lens. The exposure was 1/60 sec. at f/11 on Ektachrome 100 Plus Professional EPP film.

The key to taking a shot that shows shafts of light filtering through the trees is to provide dark contrasts for the sun's rays. For this image of The New York Botanical Garden, I moved to a point where the sun's rays had a dark backdrop. I took a spot-meter reading of the tree trunk in the light. Then I underexposed by 1/2 stop to retain detail in the foreground. Working with my Olympus OM-4T and Zuiko 180mm telephoto lens, I exposed Kodachrome 64 for 1/60 sec. at f/8.

In this New York vista, the trees frame the distant farmland and draw the viewer's eye toward the lovely grasses below. I metered the tawny grasses and underexposed by 1/2 stop to saturate their colors and darken the tree trunks. With my Olympus IS-3 and its built-in Zuiko 35-180mm zoom lens, I exposed at f/8 for 1/250 sec. on Fujichrome 100 RD Professional film.

Keep in mind that an average meter reading of a high-contrast scene usually doesn't give you a satisfactory result because it compromises what could be extreme differences in lighting. For example, if dark shadows dominate a scene, a general meter reading will cause the sunny areas to be overexposed, washed out, harsh, and lacking in detail or clarity. If, on the other hand, bright areas predominate, a general meter reading will likely underexpose parts of the scene in shadow.

You also need to decide whether you want to expose for the highlights or the shadows. If the trees are brightly illuminated, you'll want to meter the highlights. This means sacrificing the areas in shade for the sake of good exposure on the bright foliage. Letting the shadows go dark, even black, doesn't pose a problem as long as those areas are imaginatively incorporated as graphic elements in the composition. Sometimes you may prefer metering the shadows, particularly when the color element is in shade and you don't mind recording the trees as silhouettes. Any bright areas in this kind of scene will be overexposed, so be careful about where you place them in the frame.

Be sure to incorporate shadows with purpose and creativity. They can form stark lines or shapes that help organize a composition. In addition, they can serve as a foreground element that draws the viewer's eye toward the lighter area beyond, adding to the sense of a third dimension. Shadows can also form a dark backdrop that sets off a bright tree. In this shooting situation, you simply take a spot-meter reading of your subject and then underexpose by 1/3-stop intervals up to 1½ stops. This will make the shadow even darker, thereby effectively obscuring the backdrop. High-contrast film can exaggerate such differences in light and dark parts of a scene, too.

DIFFUSED LIGHT

This type of illumination offers many advantages for tree photography and deserves to be more fully appreciated. A form of gentle illumination that often filters through clouds or foliage, diffused light is relatively low in both intensity and contrast, so it is easier on the eyes and simpler to expose than bright sunlight. The delicate nature of this illumination also enhances colors, softens shadows, and reduces glare or reflections. Here are some suggestions to help you make the most of this light:

■ **Shoot subtle colors.** Diffused light brings out the best in quiet colors

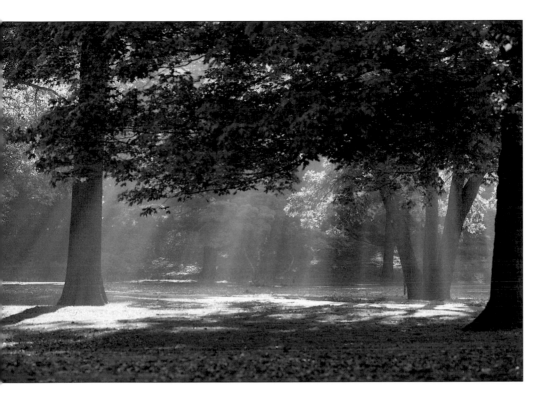

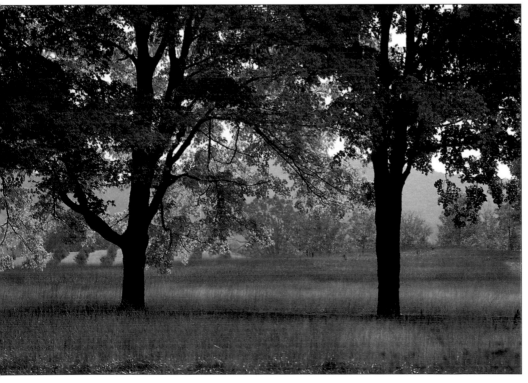

The overcast light following a spring rain can be quite flattering to shades of green, as well as a real boon for photographing in the woods. The uniform nature of this illumination eliminates all traces of shadows, thereby giving the scene an even, uninterrupted feeling. I took this shot of the wooded grounds of Winterthur in Delaware to highlight the fresh, vibrant colors. By tipping the camera down slightly, I eliminated the dull sky and featured the sturdy trunks of the foreground trees. Here, I used my Olympus OM-4T and my Zuiko 35-70mm zoom lens. The exposure on Fujichrome Velvia was 1/15 sec. at f/16.

more than brilliant colors. In the spring, this illumination makes pastels radiate. So if you want to shoot flowering cherry or crab-apple trees, this is the light to look for. Diffused illumination is also ideal for shooting fall foliage, whose browns and yellows photograph with unusual richness in it. To lighten colors even more, all you have to do is overexpose from the meter reading.

■ **Accentuate rays of light.** Whenever diffused light filters through a canopy of trees, you have a chance to capture the effect of the rays themselves. To keep the rays as white as possible, you should meter the color of the trees, and then shoot at the meter reading. Bracket toward overexposure if the trees are very dark and you want to show some detail in shadow areas.

■ **Juxtapose similar tonalities.** Filtered light handles colors of comparable intensities especially well. If you want to mix green and brown or pink and light green, you'll find that the colors stay truer in diffused light than they do in bright sunlight. Because filtered light is low in contrast, it handles low-contrast colors with respect. Simply meter the colors of the trees, not the illumination itself. You'll find that even contrasting colors are easier to shoot in diffused light than in bright sunlight because it mutes rather than exaggerates their differences.

■ **Minimize the sky.** You should eliminate or deemphasize the sky in diffused light since the sky may look unappealingly blank. You can achieve this three ways. You can move to a spot where the sky isn't visible, camouflage the sky with overhead foliage, or tip your camera down so the sky isn't included in the composition.

OVERCAST LIGHT

This light is present on rainy days and those that merely threaten bad weather. Overcast light, which is muted, plays a very special role in tree photography. It is particularly kind to colors, enriching vibrant tones and

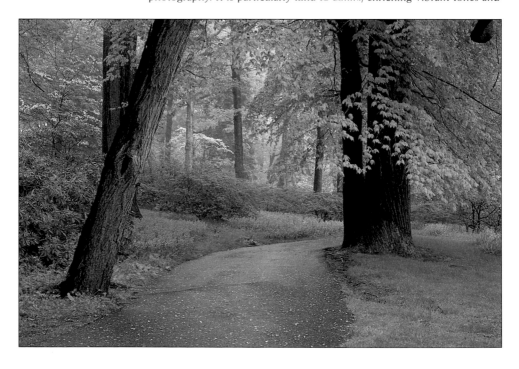

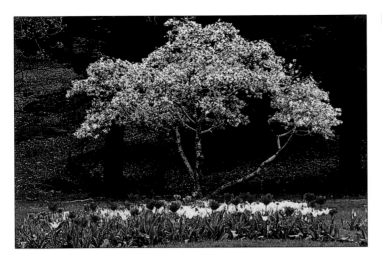

With a keen eye and a little imagination, you can make a dull day and a winter landscape work for you. When I saw these twisted trees growing in a hilly region south of San Francisco, their interesting shapes and jet black color inspired me to shoot a monochromatic image. Using the even, overcast illumination in order to play up the strengths of the image I wanted, I metered the silvery dried grasses on the ground and shot at the suggested reading. Working with my Olympus OM-4T and Zuiko 180mm telephoto lens, I exposed for 1/60 sec. at f/11 on Kodachrome 25.

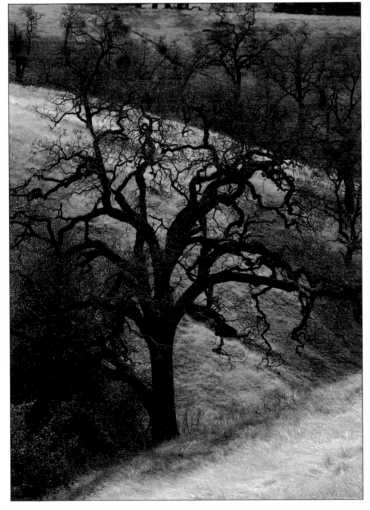

Overcast light enables you to photograph contrasting colors without having to compromise the exposure to retain detail in all the colors in a scene. To successfully record this flowering magnolia tree standing in a bed of red and yellow tulips at The New York Botanical Garden, I metered the flowers and shot at the indicated reading. With my Olympus OM-4T and my Zuiko 180mm telephoto lens, I exposed for 1/15 sec. at f/8 on Kodachrome 64.

A light spring rain intensified the greens in this Westchester, New York, county park and softened the pastel colors of the flowering magnolia, cherry, and dogwood trees. To capture these rich colors, I took a meter reading of the overall scene and shot at the suggested reading. Then to concentrate the colors and make the rain more visible, I used my Zuiko 180mm telephoto lens on my Olympus OM-4T. The exposure was 1/15 sec. at f/8 on Fujichrome 100 RD Professional film.

The mist behind this sapling reveals the fine lines of its young, fragile branches in a silhouetted image. The curve of the shoreline and the hints of other trees in the background add to the somber mood of this foggy scene in Westchester County, New York. To keep the mist white and to retain color in the leaves clinging to the tree, I metered the mist and then overexposed by one full stop. With my Hasselblad CM and an 80mm lens, I exposed Ektachrome 100 Plus Professional EPP film at f/8 for 1/30 sec.

flattering pastels. It also works wonders with monochromatic effects. When accompanied by fog or mist, overcast illumination wraps trees in a mysterious or dreamy mantle, depending on how you represent it.

Metering is usually easy when the sky is overcast because this uniform light offers little contrast. This means you can shoot at the general meter reading in most cases. And even if you're shooting high-contrast colors, you won't have to compromise your exposure in order to retain detail in both colors. Be sure not to meter the sky, though, even if it is part of your composition. Tip your camera down far enough, so that you meter only the trees or the land. And if you can, eliminate or minimize the sky in your composition, just as you would if you were working in diffused light.

RAIN, MIST, AND SNOW

Trees photographed on rainy, misty, or snowy days are particularly appealing because they are unusual. Don't let these seemingly adverse conditions stop you from going out and shooting. The special qualities of light associated with these types of weather and their softening effects combine to offer uncommon photographic opportunities to those willing to brave the elements.

The most important adjustment you have to make when you shoot is to protect your gear thoroughly. Many point-and-shoot cameras are weatherproof, so you should use one if possible in inclement weather. Today's sophisticated electronic cameras, however, are more susceptible to water damage when their circuitry gets wet than older, simpler manual models are. To keep water off your camera, wrap it in a plastic bag that you've attached to your lens with a rubber band. Cut out a hole for the lens, and keep the lens closed until you are ready to shoot. Protect it with a clear skylight filter. After taking your shot, wipe off any moisture on the filter, lens, and camera with a small towel or washcloth, and then rewrap the camera fully with the plastic bag. Keep the following photographic pointers in mind when you get started:

■ Rain intensifies colors because everything in the scene is wet and gleaming. To capture these rich colors, take a general meter reading or meter the middle tones, avoiding all very shiny spots. Bracket toward underexposure if you want to deepen the colors.

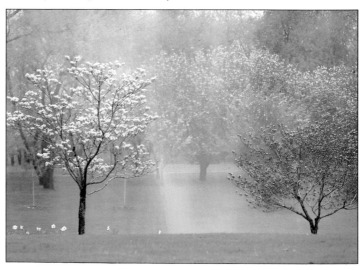

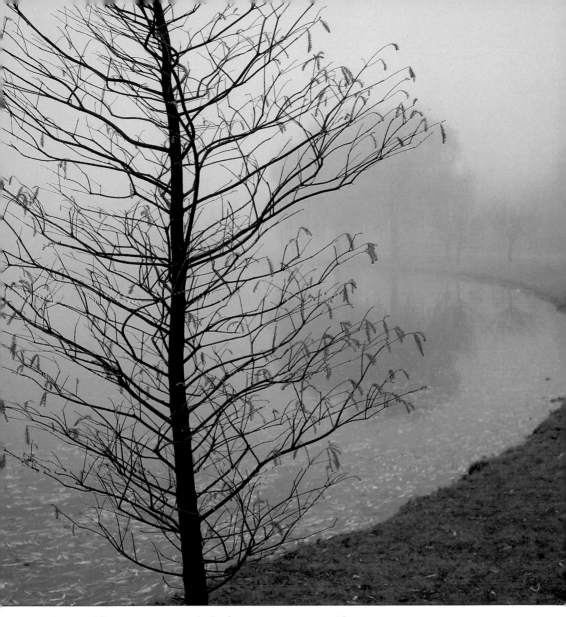

■ Mist and fog wrap trees in a cloak of mystery or romance. Notice early-morning mist rising over a pond or lake, hovering over a mountain meadow, or lingering in the woods. To keep the mist white, meter it and overexpose by 1/2 to 1½ stops.

■ Falling snow adds a rare dimension to tree photographs. Try capturing the movement of the falling snowflakes by using a slow shutter speed of 1/15 sec. to 1 full second. You can keep the snow white by following the same procedure that works for mist: meter the snow, and then overexpose by 1/2 to 1½ stops.

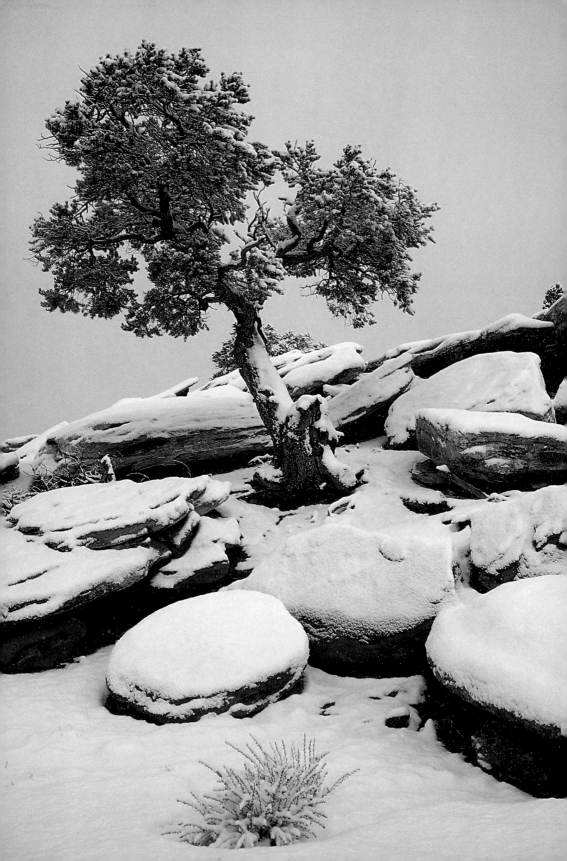

The dull illumination of a cold winter day turned this scene at Canyonlands National Monument in Utah into a virtual black-and-white study. I worked on creating a composition of simple shapes and contrasting textures, setting off the juniper tree against the massive round boulders at its base. The white sky simply repeats the overall color cast of the image. To keep the snow white, I metered it and then overexposed by 1/3 stop. Shooting with my Olympus OM-4T and Zuiko 35-70mm zoom lens, I exposed at f/16 for 1/15 sec. on Fujichrome Velvia.

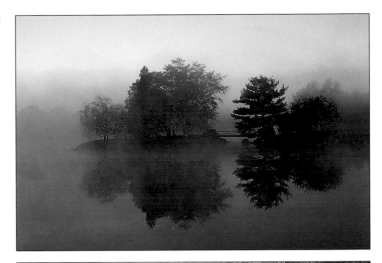

Early-morning mist rises over a lake in Ohio, and fog envelops the trees along its shoreline in a veil of mystery. To keep the scene white, I metered the mist and overexposed by one stop. For this shot, I used my Olympus OM-4T and Zuiko 35-70mm zoom lens. The exposure was 1/15 sec. at f/5.6 on Fujichrome Velvia.

Morning mist shrouds the trees flanking a boardwalk in Florida's Corkscrew Swamp. I enhanced the mysterious feeling the light created by shooting from a perspective that effectively utilized the lines receding into the unknown. Working with my Olympus OM-4T and my Zuiko 35-70mm zoom lens, I exposed Ektachrome Lumière LPP film for 1/8 sec. at f/16.

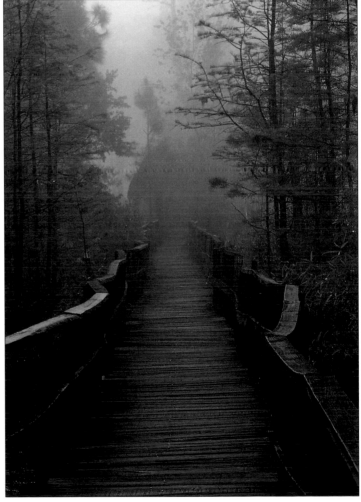

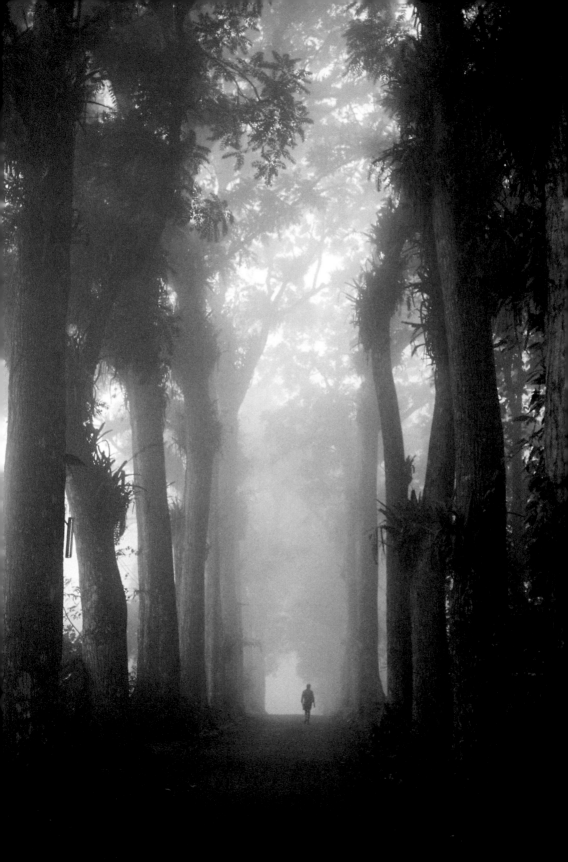

CHAPTER 4

Composing with Purpose

While working in a botanical garden in Ghana, on the west coast of Africa, I set up to photograph this group of stately trees against the morning mist. A groundskeeper suddenly walked past me and continued down the path. Immediately, I knew that I wanted to frame a composition with a human figure in it to give the tall trees some scale. I turned to my Nikkor 200mm telephoto lens, which allowed the trees to remain parallel in the frame. Then I waited until the man reached the far edge of the path, a tiny creature among giants. With my Nikon F2, I exposed for 1/30 sec. at f/16 on Kodachrome 64.

The elements of color, shape, and texture enliven this simple composition, which I photographed at The New York Botanical Garden. The deep pink blossoms of the crab apple tree truncated at the top, filling the upper band in the frame, while the lush green of the lawn fills the lower portion. The delicate illumination reveals the textures of both. Shooting with my Olympus OM-4T and my Zuiko 100mm telephoto lens, I exposed Kodachrome 64 at f/8 for 1/250 sec.

Thoughtful composition is an essential element of most successful nature photography. Fortunately, trees are cooperative, patient subjects that give you plenty of time to plan your image. Nevertheless, many photographers find it hard to look at trees and their surroundings in formal terms: as abstract visual elements on a flat plane. Most photographers are so used to interpreting the world they see as an assemblage of identifiable objects that they must make a conscious effort to view the world as an arrangement of colors, shapes, and lines.

While driving in northern Italy, I stopped to get a closer look at this unusual tree along the roadside (top). Its color and the strange way it tilted caught my eye. Once I got out of the car, I discovered a ready composition that incorporated the surroundings. I framed the tree at the apex of the converging lines of the road and fence, and then set it against the rugged Dolomite Mountains in the background by using my Zuiko 35mm medium-wide-angle lens. With this placement, the viewer's eye tends to move from the lower-right to the upper-left corner of the image. I also used my Olympus OM-4T and exposed Fujichrome 100 RD Professional film at f/4 for 1/30 sec. Then I looked for other possible shots. As I moved closer to the tree, I shot from a different perspective (bottom). Bending down so that the tree camouflaged the uninteresting sky, I composed this shot with my Zuiko 24mm wide-angle lens, which expanded the foreground, stretching it across the bottom of the frame. The converging lines now meet roughly at the center of the frame, just below the dip in the mountains. The balance here is quite different from that of the earlier shot; the viewer's eye is drawn from the lower-left to the upper-right corner. Using the same camera and film, I exposed for 1/15 sec. at f/16.

But this sort of visual objectivity is exactly what photographers need to develop in order to strengthen the impact of whatever appears within the photographic frame. This chapter analyzes the main components of good composition one by one and discusses how each one affects the final image. The choices you make at each crossroad will provide a different effect. For example, switching from a horizontal to a vertical format, changing a lens, varying the depth of field, or choosing particular exposure settings may alter the resulting image dramatically.

Of course, you should base each decision on a thorough understanding of how these technical options transform reality. This knowledge is the link between the arrangement and vision in your imagination and the one you'll actually produce. Once you master the techniques, you'll be able to create a wide assortment of images of the very same subject. Still more important, you'll be able to see the photographic potential in subjects you might ordinarily overlook.

As you read this chapter, review your own photographs and put them to the test of your new knowledge. Ask yourself how the image might have been different, perhaps better, if you'd applied some of these ideas. Then, the next time you go out to shoot, take the time to think through each step in composing until you know what you want and you've made decisions that serve that purpose. At first this process may seem unnatural, but it will become second nature after a while. When it does, you'll reap the rewards of truly stunning images.

FORMAT AND FRAMING

When you begin to compose, you should think about how you want to frame your shot. In other words, you need to make a conscious decision about exactly what should be included in the photograph. The more carefully and deliberately you frame, the more closely the final image will reflect your intentions and project your vision of your subject. You have several factors to consider as you compose; these will largely determine the picture's success.

VERTICAL OR HORIZONTAL FORMAT

Although trees are usually taller than they are wide, you shouldn't assume that every shot of a tree must be vertical. You may, for example, want to frame a tree within its setting or portray a group of trees. Alternatively, you may find a partial view of a tree more evocative than a full view. In each of these situations, a horizontal format may be more appropriate then a vertical format.

The best way to decide which format is better suited to a particular subject is to try both formats. Mount your camera on a tripod, and look at the subject through the viewfinder with the camera in a horizontal orientation first and then a vertical orientation. This strategy will enable you to see the subtle and sometimes not-so-subtle differences the two views convey. If, however, you plan to submit your images for publication, it is a good idea to shoot both formats in case a layout works better with one than the other. The point is to be flexible and to remember to check both formats before making the shot.

Placement within frame. While composing, you should also consider where to place your primary subject. Do you want the tree forward or farther back in the frame? Do you prefer centering the tree or placing it to one side? Does the row of trees look best by when shot straight on or when shot along a diagonal? Many photographers divide the frame into vertical and horizontal thirds and position their primary subject along the

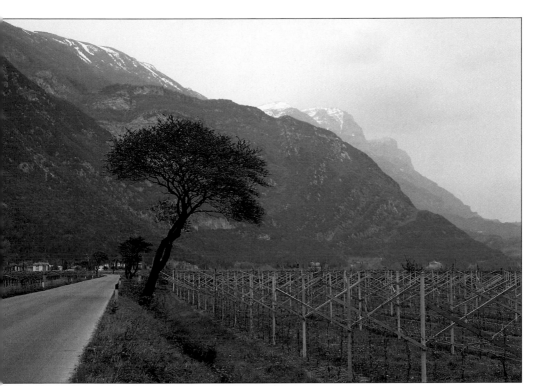

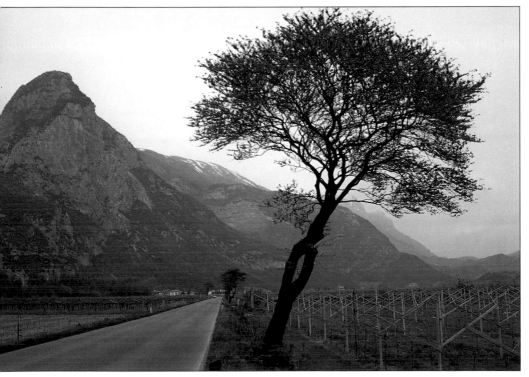

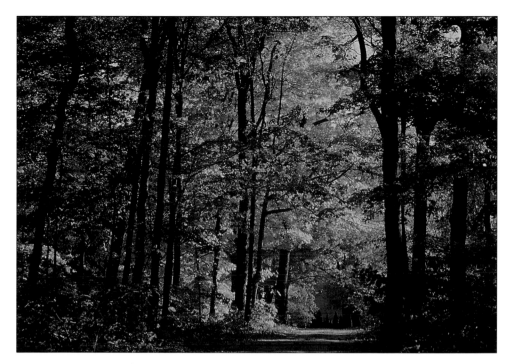

imaginary intersection of those lines. This "rule of thirds" is a good way to begin thinking about placement, but you don't need to feel completely bound by it. Move around to see what works best for you, as well as what creates the kind of balance and dynamic within the frame that actively engages the viewer's eye.

Perspective and lens choice. Many photographers get in the habit of aiming their cameras straight ahead and shooting at eye level. But a change in perspective can reveal hidden or unappreciated dimensions. This is especially true of photographing trees because it is almost impossible to shoot them at eye level. This may also explain why fewer photographers see the potential of trees or regard them as worthy nature-photography subjects.

Whatever your habit of looking may be, try a different one. For example, look up from a low perspective, as well as down from a high one, even if this means climbing a nearby hill. Being determined to find the best perspective always pays off. You should shoot both partial and full views, too. And think carefully about whether you should stand near your subject or portray it from a distance. In each case, you need to determine which lens will do the job best. Give special attention to your wide-angle and telephoto lenses.

LINES AND SHAPES

Once you've decided how best to frame your tree subject, consider how to build the composition around the combination of lines and shapes available in the scene. Of course, the lines and shapes of the trees themselves can form the basis of your image. Notice the lines the tree trunks and branches form, as well as the horizon line in the background. Arrange them in ways that have aesthetic validity beyond their documentary value.

I could have photographed this fall foliage at the Holden Arboretum in Ohio either vertically or horizontally. This horizontal framing, which I composed while using a 50mm standard lens, conveys a great deal about the environment (above); it also suggests the tunnel-like atmosphere of this densely wooded lane. Working with my Olympus OM-4T, I exposed Ektachrome Lumière LPP film for 1/30 sec. at f/16. Next, from roughly the same spot, I made another shot while using my Zuiko 50-250mm zoom lens set at 180mm (opposite page). This tighter composition and vertical framing make the rich colors and the height of the trees prominent. I used the same camera and film for this picture, but the exposure changed to f/4 for 1/60 sec.

Similarly, you can distill the distinctive shapes of trees in your photographs. Perhaps the shape is simple and elegant, such as that of a tall, slender evergreen. Alternatively, the shape may be massive, like that of like a copper beech tree. The shape may even be an irregular classic, like that of a weeping cherry tree. Another possibility is that you may be attracted to a tree for its idiosyncratic shape; a tree that may not be beautiful may still be photogenic. And the best way to make each tree's shape stand out is to isolate it or visually separate it from its surroundings.

Finally, you can opt to juxtapose the shapes of several trees in a grouping. Whether these shapes echo or contrast one another, their interplay can add an interesting dimension to your composition. In addition, you'll need to train your eye on the following elements in the environment that can represent lines and shapes in your images.

Paths and roads. A path in a woods or a garden creates a ready-made line, so you should let it serve some organizing purpose, such as adding to the illusion of depth. Depending on your purpose, you can portray the

When I saw the trees on this Dutch farm, I was amused by the contrasts they presented. One tree was in full leaf and round, while the other was just starting to bud and looked rather wispy. For this shot, I set the trees just behind the rail fence, creating a dark line that mimicked the color of their trunks. I then framed the scene with my Zuiko 50-250mm zoom lens set at 100mm so the horizon line divided the image in two. Although some photographers frown on this kind of symmetry, I think that it works here. Shooting with my Olympus OM-4T, I exposed Fujichrome 100 RD Professional film at f/8 for 1/125 sec.

This Dutch landscape illustrates the use of the vanishing point to organize the disparate elements within a composition. After selecting my 28mm wide-angle lens, I positioned myself so that the converging lines begin at each lower corner. Next, I cropped the image in such a way that the treetops fill the upper corners. As a result, the trees lining the road sweep into the distance. I used my Olympus OM-4T and Zuiko 28mm wide-angle lens, and exposed Fujichrome 100 RD Professional film at f/11 for 1/125 sec.

To my eye, the irregular shape of this bare oak tree along a northern California hillside provided a wonderful textured contrast to the well-defined shapes of the land and sky. I used my Zuiko 180mm telephoto lens on my Olympus OM-4T to take this tight shot. The exposure was f/5.6 for 1/250 sec. on Kodachrome 25.

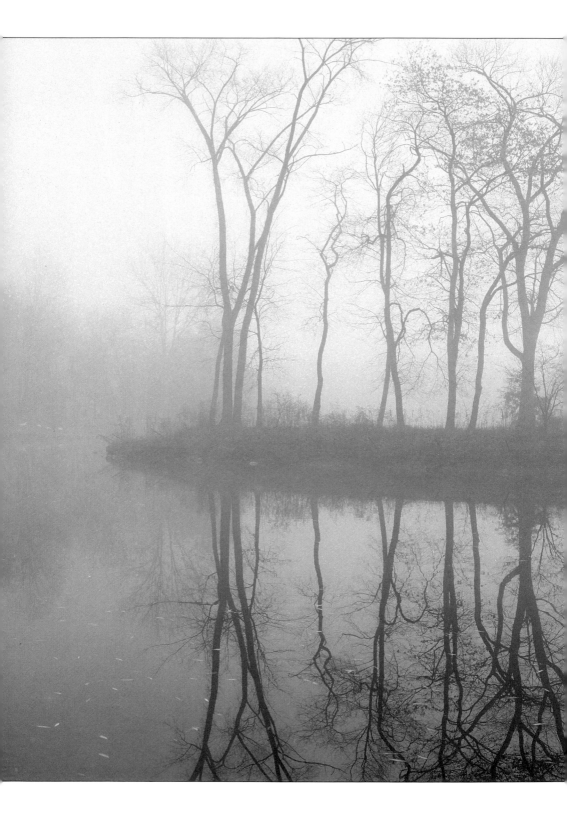

path or road as two converging lines with a wide-angle lens, or as a curve or diagonal across your tree image with a standard lens.

Land masses. The landscape itself can provide you with intriguing shapes, whether it consists of curving hills and valleys or a simple, horizontal mass. Look specifically for land shapes that set off the trees in your image, through either contrasting color, texture, or light.

Shadows and silhouettes. The shadows of the trees in your image can provide an striking complementary shape. In addition, you should pay attention to shadows of other land forms, which you can feature as blocks of gray or black. Silhouettes also register as black lines or shapes against a bright background.

Sky and clouds. Shapes above the trees can serve as interesting foils to your primary subject. A solid blue sky forms a band of color, while white clouds in a blue sky provide dramatic or charming freeform shapes. Your polarizer can help to both deepen the blue sky and brighten the clouds.

Buildings and fences. Artificial structures, such as barns and fences, can also contribute to your composition. Buildings, for example, add solid shapes. And fences serve both as lines in their own right and as linear elements that draw the viewer's eye across the plane of the image.

COLOR

Most nature photographers are naturally drawn to color. And when it comes to trees, color is readily available year-round. Think of the many seasonal changes as trees flower and as their foliage shifts from a delicate spring green to a robust summer green, and then to any of a number of rich fall colors: yellows, golds, oranges, reds, and browns. Even winter invites photographers to record on film the lovely, subtle colors of trees.

This path in a Westchester, New York, county park wends its way around the cherry tree that fills the upper part of the frame. The fallen petals along the path echo the color of the tree and soften the dense texture of the tree. Shooting with my Olympus OM-3 and my Zuiko 35mm medium-wide-angle lens, I pushed Fujichrome Velvia one stop, exposing at f/8 for 1/15 sec.

A winter fog gave me a chance to shoot with a fresh eye. These spindly trees in Westchester County, New York, turned into a tracery of intricate lines, which I played up by including their reflections. The shot is so symmetrical that determining which side is the top is hard. With my Hasselblad CM and a 150mm lens, I exposed Ektachrome 100 Plus Professional EPP film for 1/30 sec. at f/8.

I turned my attention to the base of this stand of pine trees because the fallen pine needles had become a warm russet. I composed the picture based on a horizontal band of burnt orange punctuated by vertical strokes of near black. Shooting with my Olympus IS-3 and its built-in Zuiko 35-180mm zoom lens, I exposed at f/16 for 1/8 sec. on Fujichrome 100 RD Professional film.

The Japanese maple tree in my yard turns a stunning scarlet each fall, but the color lasts only a few days. One year I took this tight shot so its color dominates the entire frame. I metered the red foliage and under-exposed by 2/3 stop to saturate the color. With my Olympus OM-4T and my Zuiko 90mm macro lens, I exposed at f/16 for 1/30 sec. on Fujichrome 100 RD Professional film.

You can arrange colors effectively within the frame by trying a number of good approaches. You may opt to fill the frame with a single color, treat a block of color as a defined shape within the image, or work as if you were using a paintbrush, emphasizing the interplay of different colors.

Technically, your main task when working with color is to expose the film properly. Remember to carefully observe how the available light affects the colors in your image. You should also notice whether the colors of the sky and water in the scene enhance the existing palette. If you feel that the sky or the water add too much blue to the scene, use a 81A or an 85 warming filter to neutralize it. You can make the most of whatever colors you encounter by exploiting the following tonalities.

Brilliant colors. The most vibrant tonalities are the rich greens of summer and the warm reds, yellows, and oranges of autumn. In order to enhance these colors, you should photograph them either in bright, low-angled backlight or in diffused, overcast illumination. Remember to meter carefully in backlight, aiming at the middle tones and overexposing slightly to accentuate the translucent effect. Determining exposure is relatively easy in uniform muted light. Simply meter the brightest color, and expose at the reading. The effects of photographing the same tree under backlit- or diffused-lighting conditions will be quite different, but each rendition will be successful.

Pastels and subdued tones. Because pastels and other subdued tones are so delicate, they lose their definition in bright light. Diffused and muted forms of illumination favor these tonalities. Expose for the middle tones, and slightly overexpose by 1/3 to 1/2 stop to soften colors and reduce contrast.

Monochromes. For an additional challenge, build your image around a single color. Such monochromatic compositions can run the gamut from

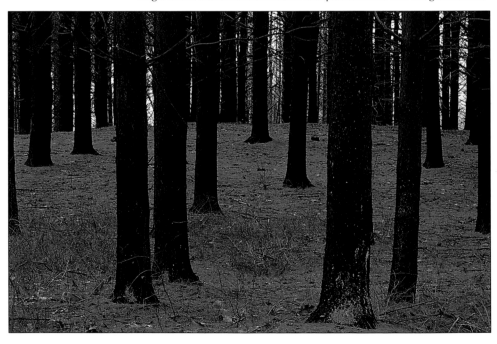

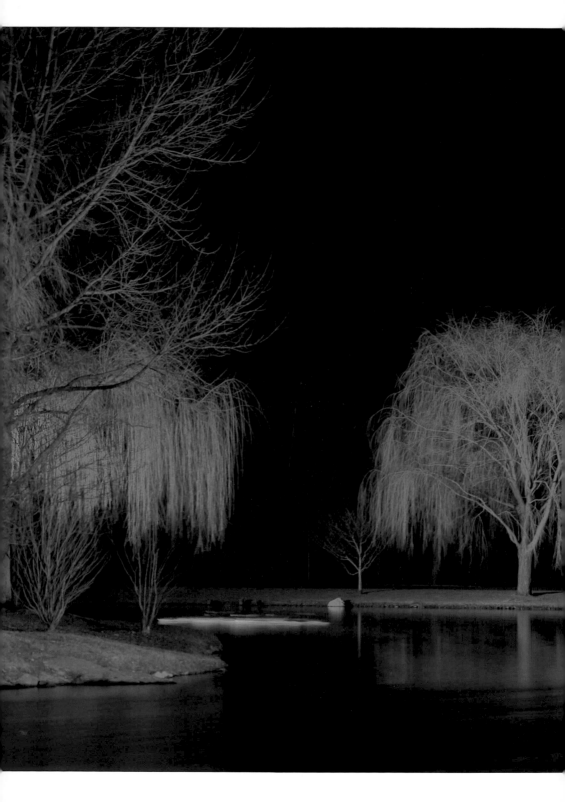

You can create unearthly colors by mismatching films and the type of light they're balanced for. In this Westchester County, New York, corporate park, mercury-vapor lamps illuminate the grounds. For this night shot of trees in the park, I used daylight-balanced film to create an eerie green. To my naked eye, the trees looked perfectly natural. With my Hasselblad CM and a 50mm lens, I exposed for 2 seconds at f/16 on Ektachrome 100 Professional Plus EPP film.

This impressionistic composition combines the sprays of pale pink of two young redbud trees with the immature greens of the forsythia shrubs behind them. To keep the tonalities light and airy, I metered the green shades and shot at the suggested reading. I used my Olympus OM-3 and Zuiko 100mm telephoto lens. The exposure was 1/125 sec. at f/8 on Fujichrome 100 RD Professional film.

The color interest in a composition doesn't have to be in the trees themselves. In this image taken in Kentucky, I silhouetted the trees against a soft palette of colors in the sky and in their reflection on a lake. I chose Fujichrome Velvia to boost the blues and pinks in the dim morning light. To retain the ethereal nature of the tonalities, I took a spot-meter reading of the blues in the reflection and then bracketed liberally. This shot, however, was taken at the indicated meter reading. Working with my Hasselblad CM and a 60mm lens, I exposed at f/16 for 1/30 sec.

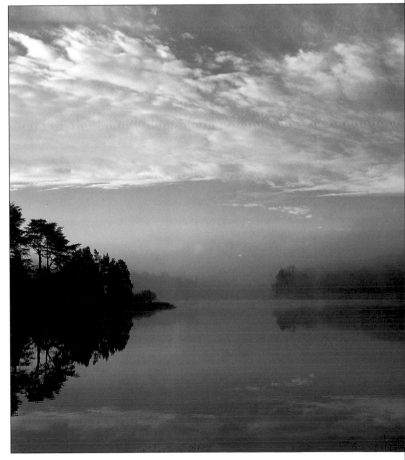

For this shot, an upward perspective produced a dramatic image. I wanted to show the texture of the bark and upper branches of these bare aspen trees in Colorado. By placing my Zuiko 35mm medium-wide-angle lens on my Olympus OM-4T, I included a considerable portion of this dense stand of trees. A polarizer deepened the color of the sky to further accentuate the textures. The exposure was 1/60 sec. at f/16 on Ekta-chrome Lumière LPP film.

Looking for the best per-spective to show this repeating pattern of olive trees in a northern California grove took some time. I wanted the irregular shapes to stand out against the yellow mustard and green grass growing on the hillside. I kept moving until I found the right direc-tion. I set my Zuiko 50-250mm zoom lens at 180mm to concentrate the colors and reveal the con-trasting pattern of trees. Shooting with my Olympus OM-4T, I exposed Fuji-chrome 50 RF film for 1/250 sec. at f/8.

I used a 50-250mm zoom lens set at 200mm to iso-late a portion of this wood-ed mountainside in Colorado. The tight compo-sition combines the repeat-ing patterns of the aspens and contrasts their texture with those of other trees. The late-afternoon diffused illumination heightens the textures by delineating each tree. To maximize sharpness throughout the scene, I used a fast shutter speed. Working with my OM-4T, I exposed Fujichrome 50 RF film for 1/125 sec. at f/8.

subtle to vibrant. For example, picture a winter scene in which a bare tree and its surroundings are dusted with snow. The resulting image might almost seem to have been shot in black and white on a gray day. At the opposite extreme, take a brilliant autumn day, one that adds sparkle to a fiery fall color. Let that one color wash across the entire frame for a breathtaking display of red, yellow, or orange.

PATTERNS AND TEXTURES

Still another way to organize your tree compositions is through repeated patterns. Such elements guide the viewer's eye and help give your com-positions order and coherence. Trees themselves can provide the repeat-ed cadences. For example, the vertical or converging lines of tree trunks may form an interesting pattern across the frame. To emphasize these recurring lines, find a location in which the trees contrast starkly with their background. You might want to look for light-barked trees against dark woods or a bright blue sky, or dark-barked trees against a lighter setting. Alternatively, you can try a diagonal placement of vertical tree trunks to draw the viewer's eye into the frame. Other objects in the envi-

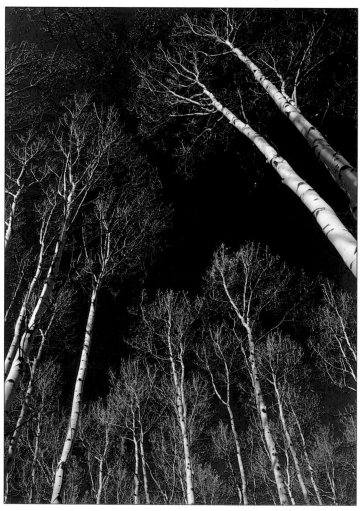

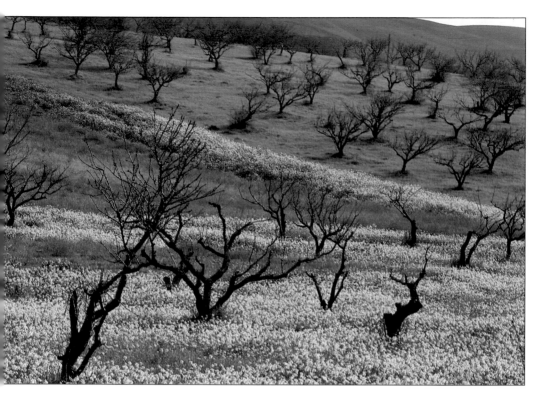

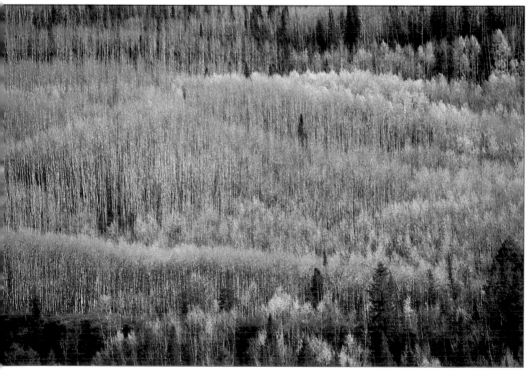

The white bark of a birch tree contrasts starkly with the scarlet leaves of a euonymus bush. I constructed this startling abstraction around color, texture, and shape. With my Olympus OM-4T and Zuiko 180mm telephoto lens, I exposed at f/8 for 1/250 sec. on Fujichrome 100 RD Professional film.

ronment can also provide rhythmic echoes. Reflections in a lake or pond are good examples, as are groupings of flowers at the base of a tree.

When you are quite a distance from the trees, these repeating patterns convey the texture of the landscape. Isolate aspects of a scene with a telephoto lens in order to graphically reveal the textural pattern of bare trees along a hillside, or the tactile quality of foliage on trees or on the ground. You may need to underexpose the scene to increase the contrast between the lighter and darker tonalities; this will help to make texture the visual focus of your composition.

ABSTRACTIONS

While showing what a particular tree looks like has documentary value, most nature photographers want to create images that become things of beauty in their own right. As you gain confidence, free yourself to see the many ways that you can portray trees. To achieve this goal, look at trees more and more as composites of color, texture, shapes, and lines. The more these subtle or bold elements come to dominate your vision, the more you'll notice trees in their most abstract presentation.

As a result of your heightened awareness, a tangle of bare trees may be miraculously transformed into a fragile lacework on film. The branches of an ordinary tree may become a ghostly, twisted, or sinister form set against a backdrop of contrasting color. And the shape of a single leaf may reach out to you in its simple clarity.

To become more observant of such possibilities, notice what moves you about a particular scene. Is it the delicacy of the trees, or their starkness? Is it the tree in combination with its setting? Is it the mood that the available light establishes, or the color? The more clearly you identify the elements that inspired your response, the more successfully you'll communicate your individual vision. Then incorporate only the most telling components in a spare image, and you'll create an abstraction of power and beauty.

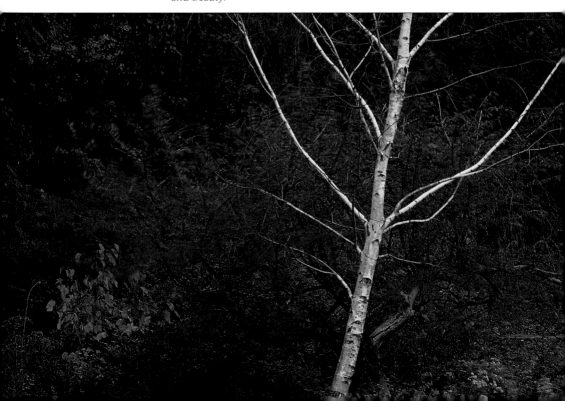

A single leaf can provide the basis for an effective abstraction. In this shot of a tropical palm leaf, I arranged my subject against a white-washed window. This approach created a simple design based on color and shape. Shooting with my Olympus OM-4T and my Zuiko 90mm macro lens, I exposed Kodachrome 64 at f/5.6 for 1/60 sec.

For this shot, I framed the top of a brilliant sugar maple tree against the azure blue of a polarized sky. The result is an abstract study in color, shape, and texture. I used my Olympus OM-4T and my Zuiko 90mm macro lens. The exposure was f/8 for 1/250 sec. on Fujichrome 100 RD Professional film.

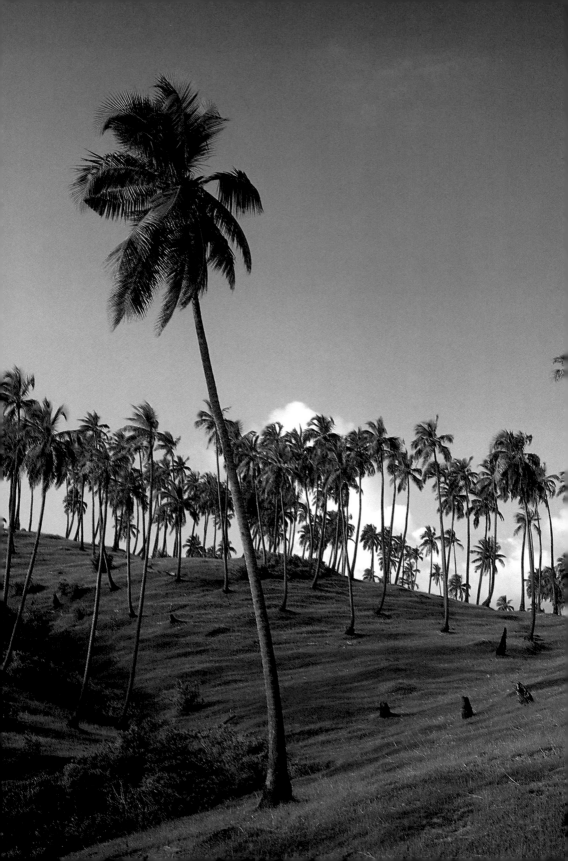

CHAPTER 5

Trees in Their Settings

In this picture of a coconut palm tree on an island in the Indian Ocean, I wanted to show the topography of the tree's setting and put it in context. To make this straightforward documentary shot more interesting, I integrated a foreground tree with the other trees in the background. With my Olympus OM-4T and my Zuiko 35-70mm zoom lens, I exposed for 1/125 sec. at f/11 on Ektachrome Lumière LPP film.

While photographing before dawn in the Bernheim Forest in Kentucky, I was intrigued by the expanse of sky that surrounded an apparently casual arrangement of trees. The natural appearance of the plantings reflects the arboretum's philosophy: to show the full shape of each tree. For this reason, I decided to silhouette the trees against the wide-open sky. With my Olympus OM-4T and Zuiko 35-70mm zoom lens, I exposed at f/8 for 1/15 sec. on Fujichrome Velvia.

L ooking at trees without considering their context is almost impossible. As natural subjects go, trees rarely stand alone, removed or isolated from their surroundings. For the most part, people look at trees and appreciate them as part of a larger setting. Trees can be found in many environments: in a meadow, along a coastline or beach, next to a road, in the woods, and in towns and cities. The more expansive the setting, the easier it is to photograph the trees.

In open surroundings, your compositional emphasis can be on the shape, color, and texture of the trees. Available light enhances each of these features. In woodlands, forests, and cities, however, you may have to work harder to find a vantage point that enables you to incorporate the setting.

Whatever that setting may be, it should become integral to your tree picture. But don't get so carried away with the setting that the tree loses its force as the focal point. Keep the composition simple; build it around the tree, with shapes, colors, and lines that leave the trees at center stage. If competing elements, such as clouds in the sky, buildings, fields, or other vegetation, are present in the scene, place them so that they don't distract the viewer.

You should also experiment with various lenses. Each lens offers different possibilities for combining a tree and its setting. Notice your distance from the tree, and then decide whether you want to incorporate the foreground, the background, or both. Select the aperture that will give your image the degree of sharpness you need. Most of all, explore the various kinds of images you can create as you move from a distant vantage point to a close one, and as you incorporate more or less of the setting. Remember, your goal is to balance the need to feature the trees with the need to incorporate an interesting, supportive context. The interplay of the trees and their setting is what creates a visually dynamic photograph.

BALANCING DIVERSE ELEMENTS

As you explore effectively placing trees in their settings, begin to imagine that the trees are lead players in a large cast. They may be the stars in the scene, but they depend on other elements—the sky, land, or water—to act as visual supports. Your composition will be stronger if you find the right balance among these elements and in their relationship to the trees in your image.

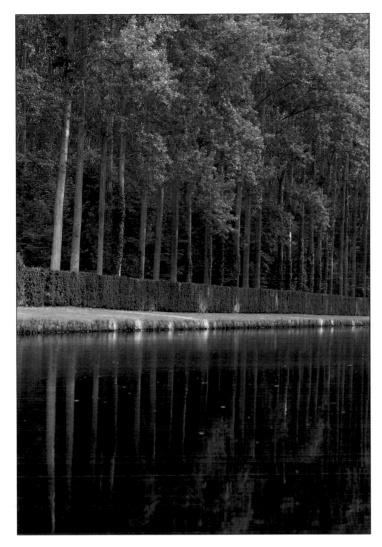

The carefully planned gardens at the chateau in Courrances, France, include a canal that reflects a row of precisely spaced poplars. I shot this scene asymmetrically, so the trees and their reflections don't quite match. Instead, the trees' foliage dominates the top of the frame, and the reflections fade into darkness. The hedge and the edge of the canal mark the distinct delineation where the two parts of the image balance. Working with my Olympus OM-4T and my Zuiko 35-70mm zoom lens, I exposed Kodachrome 64 for 1/30 sec. at f/16.

You should think of these supporting elements not as objects competing for space but as abstractions that fill a space with visual purpose. Arrange the elements in such a way that gives each its due. Weigh their individual values as shapes, lines, and colors, and consider their creative potential within the whole. The shapes and colors of the land, water, and sky may contrast with the trees, helping you set the trees apart from the setting. Alternatively, the elements may harmonize with the trees, echoing their shape or color. As you shoot trees in their environments, keep in mind some balancing elements.

Sky. The color and light of the sky may determine the type of tree image you choose to create. For example, if you come upon a sunset or sunrise sky, you may decide to portray a tree in silhouette. But if you're faced with a bright blue sky, you may want to use a polarizer in order to deepen the color; this will also allow the sky to contrast starkly with a tree's brilliant green foliage.

In Japan, garden plantings reflect a balance that imitates an idealized nature. For this shot of Takayama, I combined the trees and bridge to capture that spirit. With my Olympus OM-4T and Zuiko 35-70mm zoom lens, I exposed at f/16 for 1/60 sec. on Fujichrome 100 RD Professional film.

A hotel in Puerto Rico provided the setting for this sun-drenched image of a palm tree. I enjoyed juxtaposing the simple and the ornate elements, as well as the small echoes in the image. These include the fronds, the fountain that imitates the sea, and the stark white of the architect's creation repeated in the clouds. I used my Olympus OM-4T and my Zuiko 35-70mm zoom lens. The exposure was 1/250 sec. at f/8 on Ektachrome Lumière LPP film.

Whenever you shoot trees in an open space, notice the skyline. Make sure that the horizon line is level, and check that clouds complement the tree. If the sky is dull, let it play a minor role, camouflage it with overhead foliage, or eliminate it altogether. And use the rectangular shape of the sky either to set off the roundness of a tree, or to simply reveal a well-formed trunk and branches or the feathery fronds at the top. Be sure to notice the relationship between the sky and the trees, and utilize it knowledgeably.

Land. Like the sky area, the land portion of your image may be more or less prominent, depending on how it can enhance your tree photograph. Trees surrounded by a confusing tangle of weeds or undergrowth may look more attractive if you frame them rather tightly, without any land visible. On the other hand, a sloping hillside may add a dynamic diagonal line to your composition, while a flat horizon may convey a sense of calm. A foreground filled with flowers, shrubs, or a grassy lawn may set trees in a context of beguiling colors and textures. Meter the brightest color to get the most saturation throughout the scene.

Water. Water can be a most alluring context for trees. The water's edge forms a strong horizontal or diagonal line that can help organize your composition or direct the viewer's eye. Water can provide a strong color counterpoint to trees as well. And watery reflections can extend and mirror trees and land elements in your image in wonderful ways. Whether you want to include or eliminate such reflections to enhance the water's color, experimenting with a polarizer will enable you to achieve the desired effect. If you choose to include the reflections, meter the water rather than the trees. If the trees are brighter than the reflections, bracket toward underexposure. Conversely, if the trees are darker, bracket toward overexposure.

THE DISTANT VIEW

Whenever a lovely vista contains trees, you stand at the intersection between landscape photography and tree photography. To some extent, the setting may appeal to you more than individual trees do. But even so, the trees add something significant—texture, color, a distinctive shape—so you can legitimately consider such shots examples of good tree photography.

As you ponder the distant scene, ask yourself: How can I give proper due to the trees if I'm primarily interested in capturing the entire scene? One solution is to think of pictures of vistas these as establishing shots, the type that show the broadest perspective before homing in on specific components. Also ask yourself: How can I create a variety of images from this vantage point by turning to different lenses? Even if you can't move any closer, your equipment will permit you to create a diversity of images. You have many photographic options to choose from:

■ **Emphasize the setting.** From a great distance, you can opt to feature the landscape by incorporating trees as textural elements or identifiable shapes. These images serve either as worthwhile establishing shots or as evocative abstractions. For example, with a powerful telephoto lens, you can compress distant, tree-covered hills, thereby focusing on the abstract lines and shapes of the landscape rather than on the trees.

■ **Highlight the trees in the setting.** From a distant vantage point, a medium-telephoto lens or standard lens lets you encompass both the trees and the surrounding scene. If the foreground is particularly com-

pelling, turn to your standard or wide-angle lens to show the faraway trees in a fuller context.

■ **Isolate the trees from the setting.** Your telephoto lens lets you draw attention to a portion of a distant scene that contains trees. You may want to show a smaller section of the setting or eliminate it completely in order to emphasize the trees' texture or color.

NEAR AND FAR

As you move into the setting, one of the most fascinating challenges you'll face is photographing trees in relation to one another. The closer you get to a group of trees, the more you'll notice their changing spatial interaction. From one direction, the trees may seem to overlap, while from another individual trees may seem to have more space around them. And with one lens, they may appear quite different in size, while with another lens they may look like an undifferentiated mass.

This is why it takes considerable thought and scouting around to find the best place to shoot from. You need to find a spot that will encompass all the trees that interest you in an aesthetically pleasing arrangement. Part of this task involves effectively combining nearby trees with others that are farther away. Fortunately, the trees will wait patiently no matter how long it takes you to find a suitable vantage point. As you prepare, consider the following questions:

■ **Which lens should I use?** The farther away you are from the nearest tree, the more you can call upon your standard or telephoto lens to combine near and far trees. A medium-telephoto lens compresses space between such subjects; it also brings distant trees closer. The longer the lens, the more the distant trees are pulled forward. And the closer you are to the nearest tree, the more likely you'll need your wide-angle lens to expand your scope of vision. A wide-angle lens lets you get close to the nearest tree and still show trees in the distance; however, this lens dwarfs distant trees, so it is most useful when those trees aren't too far back.

A successful, effective approach for photographing parallel rows of trees as they go from near to far is to stack them; you simply compress the space between the trees. While working in Washington, DC, I achieved this telescoping effect at a distance of 20 feet from the closest tree by setting my Olympus IS-1's built-in Zuiko 35-180mm zoom lens at 180mm. The exposure was 1/125 sec. at f/5.6 on Kodachrome 64.

(Overleaf) One of the most reliable ways to shoot a receding row of trees is to arrange them so that they form a diagonal line across the frame. This kind of arrangement has strong graphic value and incorporates other aspects of the setting. For this shot, which I made in Holland, I went one step further; I placed the trunk of a nearby tree in a prominent position on the left for added effect. I set my Zuiko 35-70mm zoom lens at 50mm to combine the near and far trees from a shooting distance of 100 feet. With my Olympus OM-4T, I exposed Fujichrome 100 RD Professional film for 1/60 sec. at f/16.

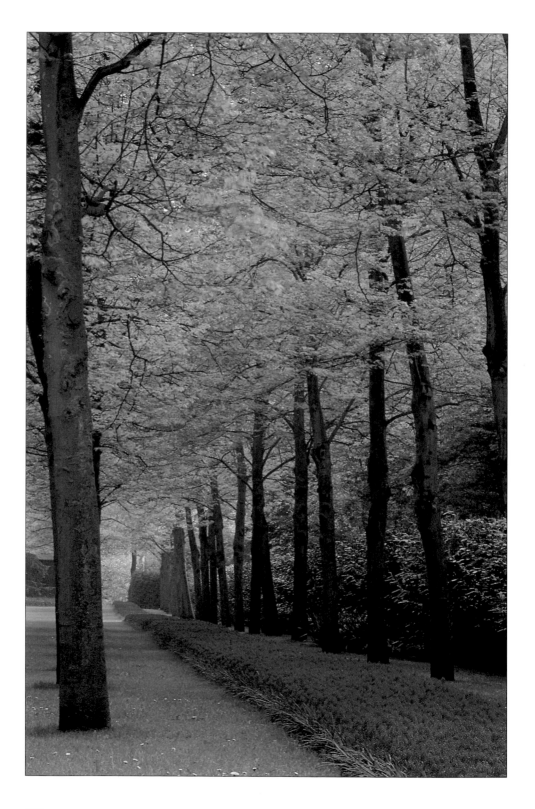

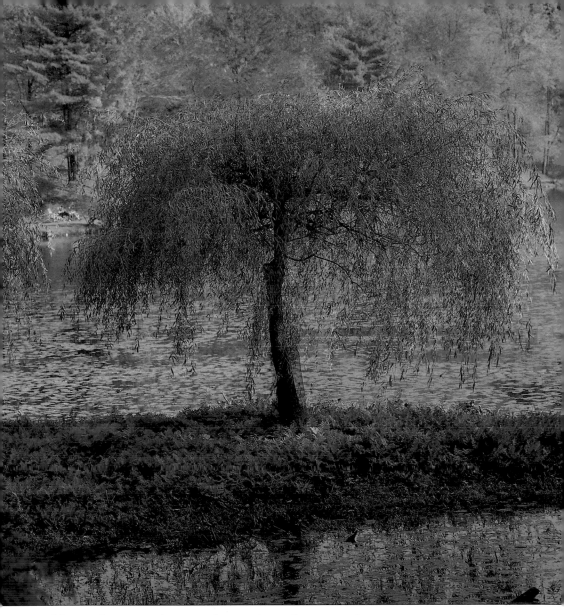

■ **How can I maximize sharpness?** Since you're combining trees that are near and far, you'll want your image to be as sharp as possible. In order to maximize sharpness in this kind of image, you should concentrate on three key factors: focus, aperture, and depth of field. First, you need to focus carefully on a point that is roughly a third of the way into the frame from the bottom. Keeping the point of sharpest focus slightly beyond or behind the nearest tree increases your range of sharpness forward and backward into the frame through depth of field. Be sure to use the depth-of-field preview button on your camera to check exactly what will be sharp in your final image. In addition, you should use the smallest aperture possible to achieve the greatest depth of field. If you mount your camera on a tripod, you shouldn't need to use a fast shutter speed when you shoot. And remember, the closer you are to the near tree, the smaller the aperture must be to produce adequate depth of field.

To capture this Putnam County, New York, garden setting I scouted out a variety of perspectives. I found one that conveyed the delicacy of the trees' textures and colors. I used my 150mm lens on my Hasselblad CM to frame the shot at a distance of 200 feet from the nearest tree. The exposure was 1/250 sec. at f/8 on Ektachrome 100 Plus Professional film.

I wanted to include an expanse of this leaf-strewn woodland path at The New York Botanical Garden to create the sense of entering the forest. While trees are visible, the path serves as a visual magnet that draws the viewer's eye forward. My Zuiko 24mm wide-angle lens enabled me to extend the foreground and maintain the depth of field I needed for a sharp image throughout. With my Olympus OM-4T, I exposed at f/16 for 1/8 sec. on Kodachrome 64.

The heather growing on the moor in front of this windswept tree in England added color and texture to the scene. I used my Zuiko 28mm wide-angle lens and tilted my Olympus OM-4T down to emphasize the foreground and limit the amount of sky at the top of the frame. After I selected a small aperture to maximize sharpness throughout the image, I waited for the wind to calm down so that I could use a slow shutter speed. The exposure was f/11 for 1/15 sec. on Kodachrome 64.

The cactus-covered foreground along this coastal scene in Mexico provided an interesting context for the palm tree. To integrate the foreground with the other elements, I had to stand among the cacti and bend down low, setting my Zuiko 35-70mm zoom lens at 35mm. I used a polarizer to deepen the colors of the water and sky, which also helped define the tree and the foreground. With my Olympus OM-4T, I exposed Ektachrome Lumière LPP film for 1/250 sec. at f/16.

EXTEND THE FOREGROUND

Sometimes the most interesting part of the setting is located in front of the trees that are your main subject. In these situations, you'll want to extend the foreground, giving it a larger space within the frame, while keeping the spotlight on the trees. Let the foreground area virtually point toward the trees or act as a visual introduction. If you can get close to the foreground elements, try shooting with a wide-angle lens with a focal length of between 21mm and 28mm. With this approach, the foreground elements will appear larger and more pronounced, while the trees will seem smaller and more distant. As a result, you must make sure that the trees retain visual integrity.

If the trees are quite a distance away, use a telephoto lens to pull them closer and enlarge them in the frame. In this way, the trees will press against the foreground elements and will appear to be in a vertical plane directly above them. Experiment with this technique if you aren't familiar with it; in time and with practice, it will become second nature to you.

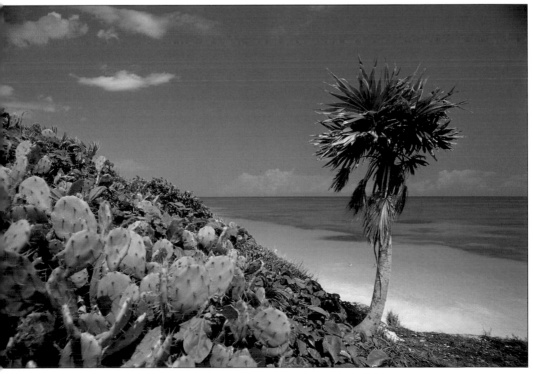

INCLUDE THE BACKGROUND

Often enough the primary setting is found behind the trees that are your main photographic subjects. When this happens, use the setting—whether it is a natural landscape or a city scene—as an evocative backdrop. Again, start by finding the best vantage point for taking the shot. Be prepared to look from above and below, as well as from eye level, particularly in settings where you can't move forward or backward freely. You should aim to frame the scene with the trees, or to use the background as a framework for the trees.

If you can't move too far back or if you prefer shooting from a close distance, use your wide-angle lens. It will help you include both the trees and what lies behind them in the final photograph. If you can't get close or if you prefer to compress the elements behind the tree, turn to your telephoto lens.

In this image, the trees dominate the foreground, and the houses in the village behind them give the scene a sense of place. My Zuiko 18mm wide-angle rectilinear lens exaggerated the size of the trees but kept them reasonably undistorted. This lens also allowed me to incorporate the background. Shooting with my Olympus OM-4T, I exposed at f/11 for 1/15 sec. on Fujichrome 100 RD Professional film.

The massive stone bridge and its reflection is the visual focus of this photograph, which I made at The New York Botanical Garden. While the background is the most prominent element, the foreground tree adds a whimsical touch of color and texture. With my Olympus OM-4T, I used my Zuiko 50mm macro lens at a distance of 10 feet from the tree. The exposure was 1/60 sec. at f/16 on Fujichrome 100 RD Professional film.

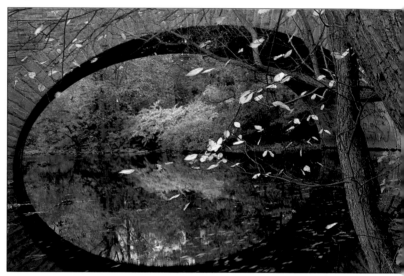

For this Holland composition, I combined the foreground poplar with a marvelous background. Each element in the image plays an important part. Every aspect of the backdrop contributes to the picture, from the canal on the left, to the colorful tulip fields in the rear, to the row of trees along the horizon. By standing on a dike that overlooked the scene and using my Zuiko 50-250mm zoom lens set at 180mm, I got the shot I wanted at a distance of 500 feet from the nearest tree. With my Olympus OM-4T, I exposed for 1/125 sec. at f/8 on Fujichrome 100 RD Professional film.

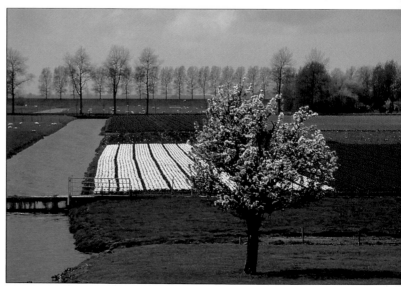

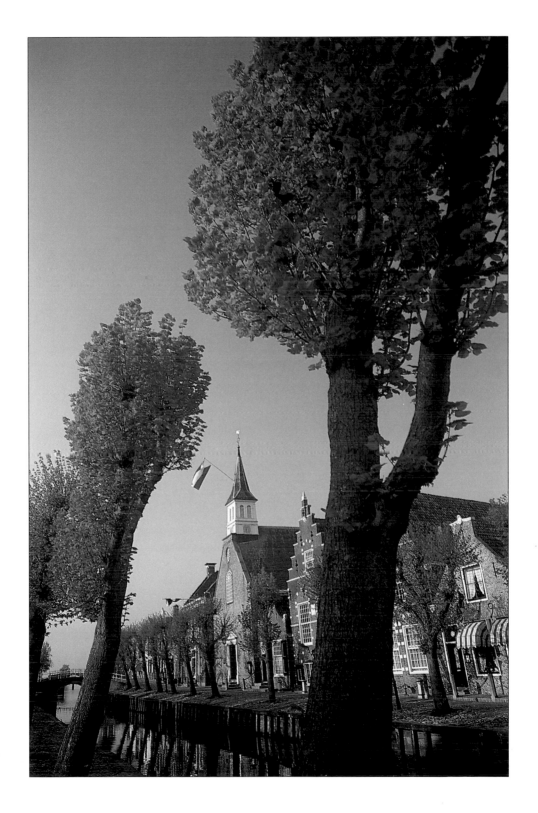

SIMPLIFY THE BACKGROUND

While shooting in a New York State park, I filled most of the frame with this massive oak tree and relied on hazy atmospheric conditions to obscure most of the background. With my Olympus IS-3 and its built-in Zuiko 35-180mm zoom lens set at 150mm, I stood at a distance of 35 feet. The exposure was 1/125 sec. at f/8 on Ektachrome 64 Professional EPX film.

In order to fill the frame with this tall oak tree and to avoid looking up at it, I had to move back about 200 feet and use my Zuiko 100mm telephoto lens. This eliminated almost everything in the background that might have competed with the tree's brilliant colors. I used a polarizer to deepen the color of the patch of sky. With my Olympus OM-4T, I exposed for 1/125 sec. at f/11 on Fujichrome Velvia

On some occasions, you may prefer to isolate trees from their surroundings. For example, you may want to focus on a tree's texture, feature its shape, or disguise an unappealing backdrop. But since trees rarely grow in complete isolation, it isn't easy to simplify the backdrop.

Perfecting your composition under such difficult circumstances takes determination and patience. Before you press the shutter-release button, check that your image includes only what is necessary, thereby eliminating or minimizing unneeded or distracting background elements. The following strategies can help you accomplish this goal:

■ **Take advantage of atmospheric conditions to obscure the background.** Bad weather often means a good opportunity for nature photography. Mist, fog, and blowing snow may give you just the right amount of cover to hide or obscure the backdrop behind a tree. Move close enough to the tree so that it is clearly visible. Then set up and wait for the decisive moment. If the atmospheric conditions are white or pale in color, take a spot-meter reading of your subject in order to avoid underexposure. A general meter reading is likely to turn the scene dark.

■ **Fill the frame with the tree.** Find a vantage point that allows the individual tree to fill almost the entire frame. If you're shooting from a short distance, use your wide-angle lens to encompass the entire tree. From a greater distance, experiment with your telephoto or zoom lens until you achieve the right composition. You may find that you have to get down low and angle your camera upward. If the sky behind the tree is blue, check to see if your polarizer improves its color. If the sky is overcast, tip your camera down just a bit so that the top of the frame doesn't look like a blank, white area.

■ **Utilize contrasts of light and color.** A good way to separate a tree from its surroundings is through contrast. For example, you may decide to set a brightly illuminated tree against a background shadow. Color

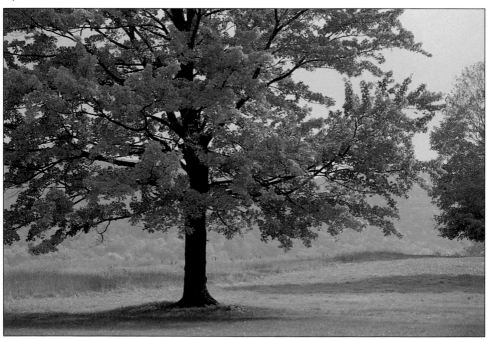

108

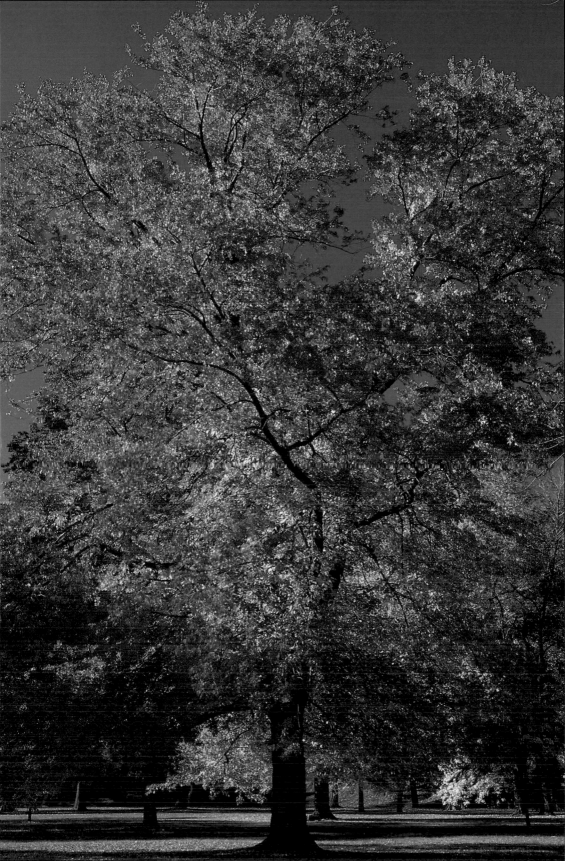

I found this delicate weeping cherry tree in front of a tangled, wooded backdrop at The New York Botanical Garden. To simplify the background, I filled the frame and limited the depth of field by setting my Zuiko 180mm telephoto lens at a fairly wide-open aperture, f/5.6. Working with my Olympus OM-4T, I exposed for 1/250 sec. on Fujichrome 50 RF film.

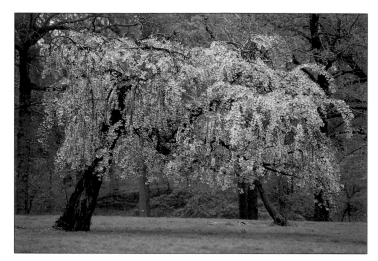

This solitary tree standing in a Spanish field needed the simplest possible backdrop to reveal its distinctive shape. Fortunately, the sky provided that background via a wonderful contrast of light and color. I chose my Zuiko 35mm medium-wide-angle lens in order to incorporate an expanse of this unassuming backdrop. I shot at f/8 to achieve maximum sharpness in the haystacks and the sky. With my Olympus OM-4T, I exposed Fujichrome 100 RD Professional film for 1/250 sec.

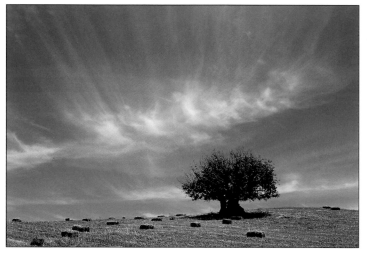

When shooting these trees along a road in the Dutch countryside, I didn't want the background to disrupt their visual flow or detract from them. So by massing the trees with my Zuiko 50-250mm zoom lens set at 200mm, I made the distant trees serve as an effective backdrop for those in the foreground. This telescoping effect created a dynamic line on the ground, as well as a strong V-shape in the sky, drawing the viewer's eye down along the smooth row. With my Olympus OM-4T, I exposed Ektachrome 100 Lumière LPP Professional film for 1/4 sec. at f/11.

contrasts can also help separate a tree from the background. The white or pink flowers of a dogwood stand out sharply against a dark green woodland. To play up such color contrasts, look for ways to set pastel-colored trees against deeper colors in the background. If all else fails, look skyward for a possible backdrop that provides contrasts in terms of both color and light.

■ **Minimize depth of field.** An excellent way to create an uncluttered backdrop is to establish shallow depth of field. Because this area of sharpness in front of and behind a subject decreases as you move closer to your subject, select a wide-open aperture or work with longer lenses. For example, use a 100-200mm telephoto lens from a fair distance at a wide-open aperture setting to blur out a tangled scene behind a tree. This technique works best if the tree and background are reasonably far apart. Look through your lens, using your depth-of-field preview button, to see the exact effect that will appear in the final image.

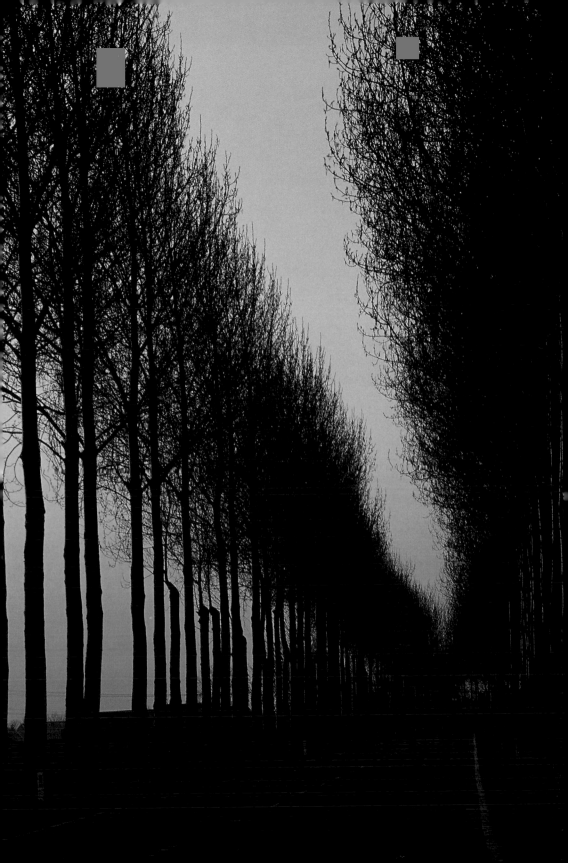

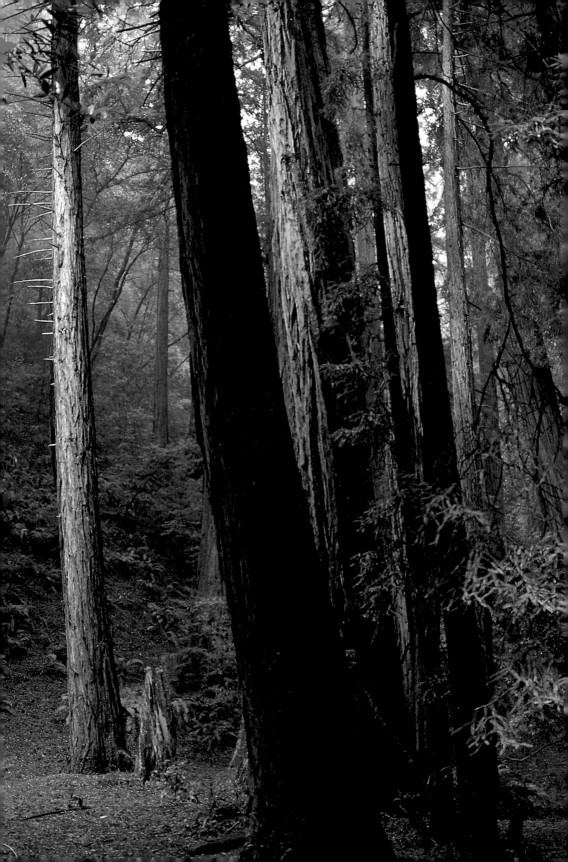

CHAPTER 6

Developing Perspective

You don't have to photograph an entire tree to convey its grandeur. While shooting this forest scene in California's famed Muir Woods, I limited my perspective to the tall trunks of the foreground evergreen trees. In order to suggest the forest setting, however, I made sure that this perspective included plenty of background greenery. Next, I worked on interpreting the composition as a series of strong vertical lines and as an interesting pattern of light and shadow. Working with my Olympus OM-4T and Zuiko 35-70mm zoom lens, I exposed for 1/30 sec. at f/11 on Fujichrome Velvia.

I deliberately chose a low perspective for this shot of trees at Winterthur, Delaware; I wanted to encompass as many of the colorful spring flowers planted around their base as possible. This kind of perspective works well whenever what is on the ground adds to the visual impact of your tree image. With my Olympus OM-4T and my Zuiko 35-70mm lens, I exposed at f/16 for 1/8 sec. on Fujichrome 100 RD Professional film.

Most people tend to look at the world at eye level, and with the perspective their eyes are capable of. And when people pick up a camera, they often forget that other viewpoints, or ways of seeing, exist. If you are in this kind of visual rut, it is time to escape by changing the way you ordinarily look at or photograph trees. After all, one of the reasons photography is so much fun is that the camera and a variety of lenses can literally extend your eyes. This combination of equipment can move you closer, enlarge what you see, or open up strange, somewhat distorted points of view that produce exciting images.

Chances are that you need a little shaking up in this area, and this chapter will show you how to exploit different perspectives. Begin by shooting from anything but eye level. For example, get down on the ground and look up at the trees, or climb a hill and look down at them. If you're fixated on one particular lens, leave it home and experiment with other lenses. Take only one lens at a time to increase your creativity by fully exploring its potential. Do you tend to take pictures in the middle of the day? See how different the world looks at dawn or at dusk. And if you are a fair-weather photographer, go out after a rainstorm or during a snowfall and discover what a change in the weather can do.

Another technique to help you develop new perspectives when photographing trees is to give yourself an assignment for each shoot. One that our workshop participants have liked requires them to find a promising location, then start by shooting the entire scene, including the trees. After that, they have to complete the following picture sequence: home in on a grouping of trees, shoot a portrait of two trees, compose an image of an individual tree, and, finally, feature parts of a tree. Each time you look for another perspective or search for an alternative photographic solution when you shoot, you stretch your imagination and produce more original shots.

GROUPING TREES

In nature, trees aren't arranged in aesthetic groupings. It is up to photographers to find a perspective that shows the relationships among trees. You can base your grouping on such purely formal considerations as similarities or differences in color or light, a harmonious interplay of lines and shapes, and surprising elements of dissonance. For a documentary perspective, you may either show a group of trees that share a particular environmental niche, or suggest the roles that trees play in people's lives.

If your space is limited, as in the woods, and you're working with a 35mm medium-wide-angle lens or a 50mm standard lens, you may be

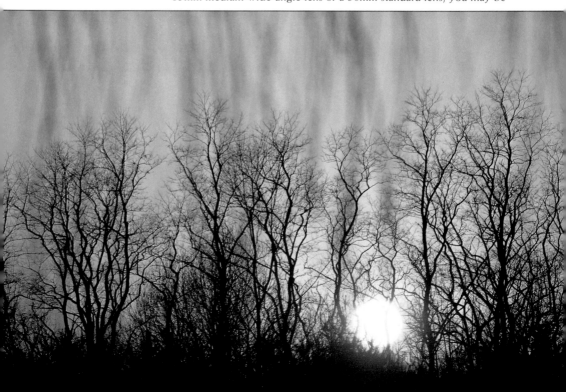

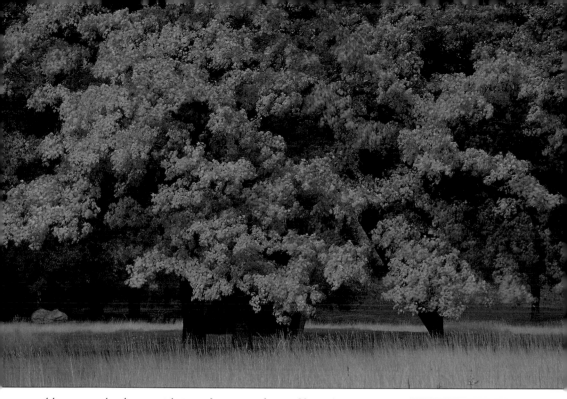

able to record only a partial view of a group of trees. Your composition could feature the base and roots with just a bit of foliage showing. Another option is to spotlight the trunks. Here, you build the image around the strong vertical lines of several trees, and let the foliage act as a color fill in the background.

If, however, you're working from an intermediate distance—50 to 300 feet—a telephoto or a zoom lens in the 80-200mm range can portray a group of trees as a pattern of lines, colors, and shapes across the frame. And if you're shooting from a closer distance—15 to 30 feet—a medium-wide-angle lens or a standard lens can highlight contrasts of color and texture between a group of trees and their surroundings; at the same time, either type of lens can simplify or eliminate the backdrop.

When you photograph tall trees, try an upward perspective with a wide-angle lens. But be careful that this viewpoint doesn't cause too much image distortion or include too much of a dull, colorless sky. If the light on the various trees is uneven, set them off against one another, letting some serve as foreground subjects and others as background elements. Find the best perspective you can, given your distance from the trees, and frame tightly.

THE INDIVIDUAL TREE

Nature rarely presents photographers with the opportunity to portray an individual specimen. Yet this most classic perspective, which shows an entire tree, enables viewers to explore and truly appreciate the qualities that make each tree special. People soon realize that one tree isn't just like another, despite apparent similarities. For example, one weeping cherry tree may curve subtly to the left, while another may lean to the right. A maple tree stretches its branches in unpredictable directions, while a Douglas fir stands as erect as a soldier. Even a less-than-perfect specimen can inspire you to create an image full of life and visual power.

An effect that truly excites me is one that features contrasting textures. That is what I was looking for in this autumn scene, which I photographed at the Storm King Art Center in New York. In order to fill the frame with the muted golden leaves, I grouped several trees and framed them tightly using my Zuiko 35-180mm zoom lens set at 150mm. I cropped off their tops to create the desired illusion: that there is only one tree. As a result, the mass of leaves contrasts more graphically with the grasses below. Working with my Olympus IS-3, I exposed for 1/125 sec. at f/5.6 on Ektachrome 64 Professional EPX film.

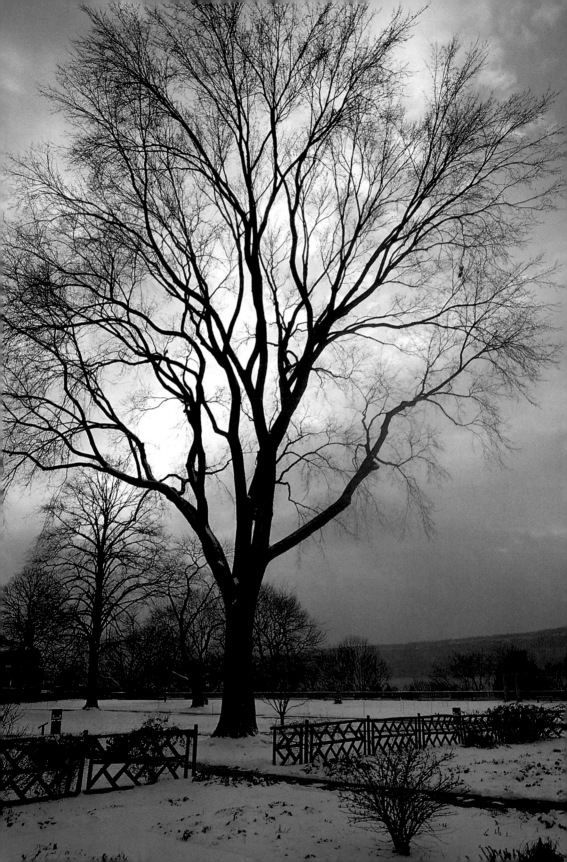

Think of an ancient juniper that has twisted down the side of a cliff or a windswept pine along a rugged coastline.

Every lens in your camera bag will serve you well in achieving solitary perspectives. If you're shooting from a distance of 100 to 200 feet, a 100mm telephoto lens will capture both the entire tree and a portion of the setting. From a working distance of 50 feet, a 35mm medium-wide-angle lens or a 50mm standard lens will produce the same result. To make your image special, however, be sure to walk around the tree until you discover the direction that reveals the strongest shape and most appealing surroundings.

You should avoid shooting a full view of a tree from relatively short distances. But if you decide to try this approach, you must be able to come to terms with the inevitable distortion that occurs when you tilt the camera upward. It is preferable to opt for a partial view of the tree, possibly with its setting, using a 35mm medium-wide-angle lens or a 50mm standard lens.

Through the careful observation of individual specimens, particularly those at close range, you can begin to see each tree as a remarkable and lovely work of nature. Using your camera, lenses, and film the way an artist uses crayons, pencils, brushes, and paints, you can shape an image that permits an individual tree to realize its aesthetic potential. And by capturing the essential character of each tree on film, you can separate it from the crowd for leisurely contemplation and appreciation.

PARTS OF A WHOLE

When you shoot from a close perspective, try to fill the frame with parts of an individual tree. Such moderate closeups may feature a tree's foliage, branches, trunk, and bark, thereby revealing shape, color, texture, and line. As you look at a possible subject, break down the whole into its components and consider what is dominant. Is it the soft, wispy nature of

When I noticed this solitary tree along the water's edge at The New York Botanical Garden, I moved in close, to a distance of 10 feet, to fill the frame with only the lower part of the tree. Using my Olympus OM-4 and Zuiko 28mm wide-angle lens let me include enough of the misty green setting to provide a context for this isolated tree. The exposure was 1/30 sec. at f/11 on Kodachrome 64.

This tall sycamore tree at Wave Hill in New York demanded to be photographed in isolation. Taking advantage of the winter landscape, I made this image a virtual black-and-white study. From a distance of 30 feet, I used my Olympus OM-4T and my Zuiko 28mm wide-angle lens. The exposure was 1/60 sec. at f/8 on Fujichrome 100 RD Professional film.

Rather than point my camera skyward in this forest of tall fir trees in northern California, I chose a partial perspective. This point of view let me not only avoid the distorting effect that shooting upward would have produced, but also focus attention on the trees' most fascinating facets: the slender trunks with their one-sided branches. The graphic effect is heightened by the eerie illumination, which is a combination of mist and low-angled sunlight. Working with my Olympus OM-4T and my Zuiko 50-250mm zoom lens, I exposed for 1/30 sec. at f/8 on Fujichrome 100 RD Professional film.

a weeping willow? The gnarls and knots of an old beech-tree trunk? The delicate lacework of a cherry tree's bare branches in winter? The rich glow of a maple tree's leaves in autumn?

Whatever aspect you decide to emphasize, don't try to cover too much ground. Select a single, strong dimension—two at most—and work on depicting it as clearly and simply as you can. The following suggestions should help you get started.

Foliage. When you look at foliage, think in terms of color and texture, both of which the play of light enhances. In order to highlight the texture of a tree's foliage, position yourself at a right angle to the sun, so that your subject is in intense sidelight; this is low-angled sunlight that hits the subject from the side. To achieve the most vibrant color possible, position yourself in such a way that enables you to record the foliage in backlight. Here, light passes through the foliage on its way to the lens. Next, carefully take a spot-meter reading of the foliage, and bracket toward underexposure to deepen the color.

Branches. A tree's branches become lines in your composition. They may be fine tracery, heavy brush strokes, long needles, or contorted squiggles. Whatever their thickness and direction, a tree's branches will appear darker and more clearly defined if the tree is backlit. You can create interesting compositions by using bare branches alone, as well as by combining them with backlit foliage. For examples of how to arrange branches in your frame, take a look at classic Japanese or Chinese paintings, which often include one well-formed branch as a strong linear element in an otherwise delicate scene.

Trunk. Shape and texture overshadow color as dominant features in tree trunks. You may fill the frame with little more than the trunk itself for a

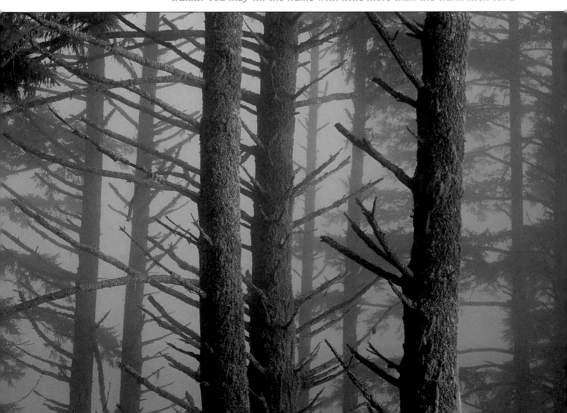

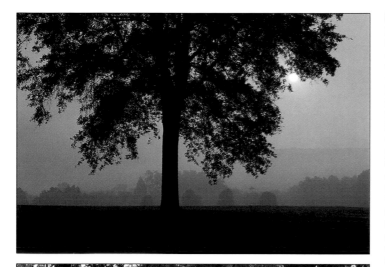

Even when I've photographed an entire tree, I experiment with evocative ways of showing it in a variety of partial framings. Here, I decided to try a tight cropping that lops off the top of this elm tree at Kentucky's Bernheim Garden. I thought such a perspective would permit the soft shapes along the distant horizon to gain some prominence. Whenever I want something toward the bottom of the frame to get visual attention, such as flowers or landforms, I compose so that the tree fills the upper part of the frame. With my Olympus OM-4T and my Zuiko 35-70mm zoom lens, I exposed at f/11 for 1/8 sec. on Fujichrome 100 RD Professional film.

Your own yard and garden can be sources of fine tree images. I made this backlit shot of a Japanese maple tree in my front yard to emphasize the rich colors of its foliage and feature the meandering lines of its branches. To achieve this perspective, I had to climb under the low-lying tree; I also had to use my Zuiko 21mm ultrawide-angle lens at a distance of 2 1/2 feet from the trunk. To saturate the fall tonalities, I metered the leaves and overexposed by one full stop. Shooting with my Olympus OM-4T, I exposed for 1/15 sec. at f/8 on Ektachrome 64 Professional EPX film.

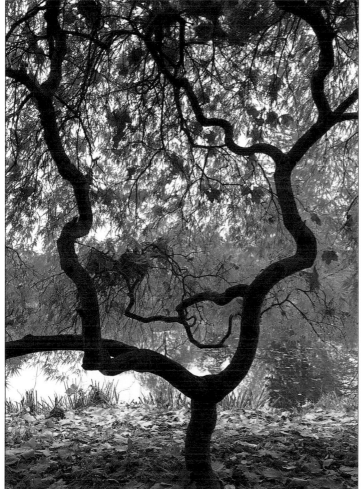

I wanted to contrast the solid shape of this tree with the delicate textures and colors of the grasses surrounding its base. I chose a perspective that showed only the tree trunk in order to make the contrast more startling, as well as to play up the grasses. I used my Olympus OM-4T and my Zuiko 100mm telephoto lens. The exposure on Fujichrome 50 RF film was 1/125 sec. at f/8.

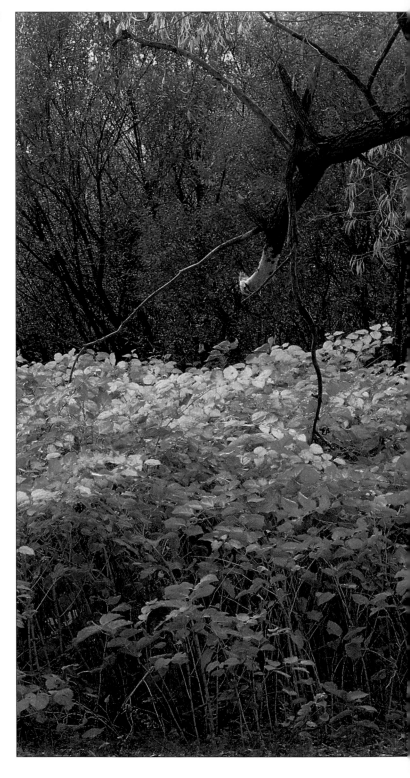

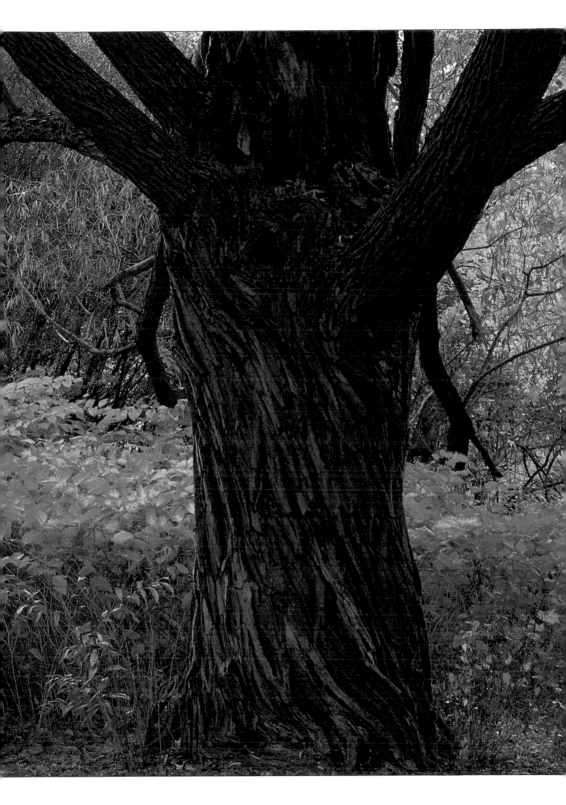

This elegant fir tree seemed to stand guard over the jagged northern California coastline. To capture it in silhouette, I waited for sunset. I metered the misty clouds on the horizon and underexposed by 1/2 stop in order to deepen the colors, and to turn both the tree and the land black. I used my Olympus OM-4T and my Zuiko 50-250mm zoom lens. The exposure was 1/30 sec. at f/8 on Fujichrome 100 RD Professional film.

When I came upon this elm tree in Kentucky's Bernheim Forest, I thought that shooting a silhouette was the best way to show its lovely roundness. To do this, I arrived at the scene before sunrise. A thick layer of mist covered the ground, a heavy cloud hung over the horizon, and wisps of clouds hovered overhead. I metered the clouds that were closest to neutral gray and shot at the indicated meter reading. With my Olympus OM-4T and my Zuiko 35-70mm zoom lens, I exposed at f/11 for 1/30 sec. on Fujichrome Velvia.

I keep shooting well after the sun has gone down. I know that even if the sky is fairly dark, I can get rich colors to play off the trees I'm photographing. While making this silhouette in Everglades National Park in Florida, I metered the sky and overexposed by one full stop to brighten what was already a very dark sky. Shooting with my Olympus OM-4T and my Zuiko 50-250mm lens, I exposed for 1/15 sec. at f/5.6 on Fujichrome 100 RD Professional film.

true closeup. Another alternative is to set a solid trunk shape against more delicate elements that surround it. For example, a tree trunk combines well with nearby grasses, with flowers at its base, and with fallen leaves at its roots. Be sure to position the trunk off center to avoid a dull, symmetrical arrangement in the final image.

If you also want the texture of the bark to show, you should expose for the tree trunk, not the background. This effect works best in diffused light. This type of soft illumination reduces the contrast between the dark tree trunk and any nearby flowers or foliage.

SILHOUETTES

Silhouettes are among the most expressive ways to shoot trees. The resulting images abstract the shape of a tree and allow it to dominate an otherwise simple composition. Tree silhouettes can combine with background colors, nearby landforms, and bodies of water to convey nature's essential beauty and serenity.

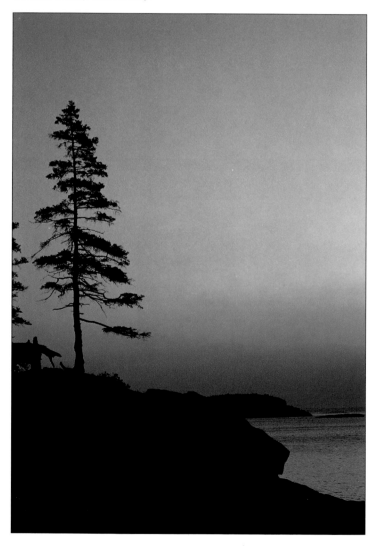

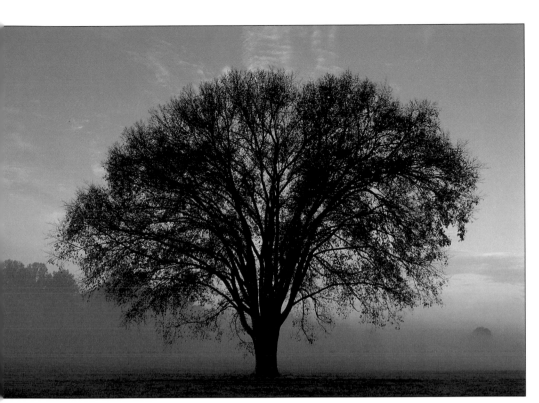

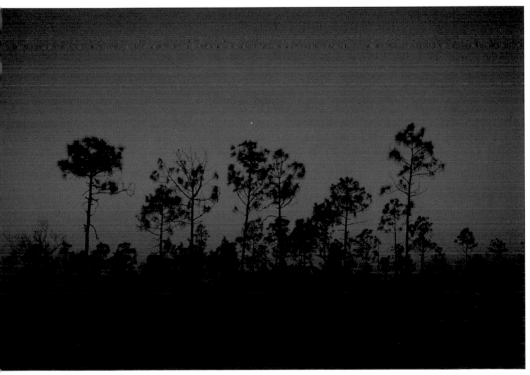

I was fascinated by the way the strong sidelight brought out the graphic lines embedded in this leaf's surface and made the color especially vibrant. In order to capture all the details, I used my Zuiko 90mm macro lens and photographed from a distance of just 7 inches. At such close range, I had to work to get everything sharp. So I mounted my Olympus OM-4T on a tripod, focused on the leaf's veins, and chose a small aperture. The exposure was f/22 for 1/15 sec. on Fujichrome 100 RD Professional film.

Silhouettes require backlight. It is best to shoot them around sunrise and sunset when the color of the sky plays an important supporting role. You can also produce effective silhouettes in mist and fog; just make sure that the background is brighter than the tree. In any event, the backdrop should remain simple, clear, and unobstructed so that the form of the tree stands out.

In general, if the sky is too bright, it won't offer enough color contrast to make a silhouette interesting. But an underexposed sky may cause parts of the tree to merge with the background. As a result, you should base your exposure on the background colors but think carefully about how best to meter the scene. Here are some suggestions for accurate exposure:

■ Meter the sky, not the tree or the land. In a silhouette, you want the tree and even parts of the land to be black.

■ If the sky is uniformly bright, enrich the color of the sky by underexposing up to one stop.

■ If the sky contains areas of varying brightness, such as when there are clouds in the sky or if the sun is still visible, you should meter the area that is closest to neutral gray. Then bracket 1/2 to 1 full stop toward both over- and underexposure in order to get a shot with the color rendition you want.

■ If the sun has gone down and the sky is fairly dark, meter the sky and overexpose up to 1½ stops to brighten the sky.

CLOSEUPS AND DETAILS

Trees offer some excellent opportunities for shooting details at very close range and this perspective can have all the vigor and power of closeups in other aspects of nature photography. For some subjects—flowers, leaves or fruit—you may have to concentrate on trees that are not particularly tall, but that is not a major problem. As for bark and leaves that

The bark of this eucalyptus tree in The Atlanta Botanical Garden was a ready-made abstraction. Low-contrast, overcast illumination complemented the soft, muted colors. I decided not to completely fill the frame with the bark, so a bit of the background shows and adds some color to the image. I used my Zuiko 90mm macro lens at a distance of 12 inches, metered the light part of the bark, and shot at the suggested meter reading. With my Olympus OM-4T, I exposed at f/5.6 for 1/125 sec. on Fujichrome 100 RD Professional film.

have fallen to the ground, nearly all trees can oblige. Here are some specific suggestions for shooting details.

Bark. You can bring out the texture of bark by shooting in fairly high-contrast light. This creates both highlights and dark shadows that emphasize the bark's surface irregularities. Shoot from a distance of at least 6 to 12 inches in order to maximize textural sharpness. Getting any closer to your subject will limit depth of field, which in turn might cause some blurring if the bark is deeply ridged. Fill the frame with the bark so that no background shows, and expose for the highlights so that the colors in the scene remain rich and saturated.

Leaves. Emphasize the color, shape, and graphic lines embedded in leaves. When the leaves are on the tree, their colors look particularly vibrant in backlight or sidelight. When the leaves are on the ground, their colors photograph best in the uniform light of overcast or rainy days. If the wind is blowing while you're shooting, use a fast shutter speed or wait until the breeze has died down.

To bring out the texture of the bark in this closeup, I took advantage of the fairly contrasty illumination. In addition to emphasizing surface irregularities, this light enriched its colors, which I enhanced with Fujichrome 100 RD Professional film. I deliberately filled the frame with the bark to eliminate the background, metered the highlights, and shot at the indicated meter reading. The relatively small aperture increased the textural sharpness. Working with my Olympus OM-4T and my Zuiko 90mm macro lens at a distance of 10 inches, I exposed at f/11 for 1/15 sec.

This abstract composition represents an imaginative combining of fallen leaves with the end of a weathered log. I skewed the image to create a dynamic tension between diagonal lines, light and dark tonalities, and rough and smooth textures. With my Olympus OM-4T and my Zuiko 35-70mm zoom lens, I exposed Fujichrome 100 RD Professional film for 1/8 sec. at f/16.

Flowers, Fruit, and Berries. Unless a tree is low to the ground, you may have a hard time photographing these details. Even at eye level, flowers, fruit, and berries present a number of difficulties because you can't easily isolate them from their backgrounds. Be sure to notice any bright hot spots in the background, and reposition yourself to avoid them. If possible, set the detail against a shadow that will record as a lush black in the final image. If this isn't possible, use a telephoto lens with a wide-open aperture. This technique will camouflage an unwanted backdrop by throwing it out of focus.

To photograph true closeups, you need some specialized equipment. You have three options to choose from. How often you plan to shoot closeups will determine your decision.

■ Working with a macro lens is the easiest way to shoot closeups. These lenses are specifically designed to be used from very small distances. Macro lenses offer two other advantages as well: they don't require any accessories, and they don't result in light loss. But macro lenses, which come in focal lengths ranging from about 50mm to 200mm, can be expensive.

■ Extension tubes are a considerably cheaper alternative to macro lenses. However, because you must place the tubes between your camera body and lens, they restrict the working distance to the subject. So, when you want greater magnification, you need to add another extension tube.

■ Closeup lenses that screw on to your 50mm standard lens are the least expensive option. Keep in mind. however, that they produce the least sharp images. As with extension tubes, you're limited to a narrow working distance, but you can combine two or three closeup lenses to increase magnification.

At very close range, sharpness is of primary importance. So you must keep your camera on a tripod, focus on the most desired part of the detail, and use a small aperture. You may want to add illumination with your electronic flash unit; this will permit you to stop down to a smaller aperture for increased sharpness throughout the image.

Whatever perspective you choose, your imagination and photographic skills can now work together to help you create images that are as appealing as the trees themselves.

Index